THE EYE OF EISENSTAEDT

THE EYE
OF
EISENSTAEDT

Life Photographer

ALFRED EISENSTAEDT
as told to Arthur Goldsmith

THAMES AND HUDSON · LONDON

FIRST PUBLISHED IN GREAT BRITAIN IN 1969 BY

THAMES AND HUDSON LTD, LONDON

PRINTED IN U.S.A.

CONTENTS

IN THE BEGINNING 7
HOW I BECAME A PROFESSIONAL 21
LEARNING TO BE A PHOTOJOURNALIST 34
A SENSE OF TIMING 56
A FEELING FOR LIGHT 77
PEOPLE 94
THE DISCOVERING EYE 123
BIRDS, ANIMALS, AND PETS 152
CANDID PHOTOGRAPHY 160
PHOTOGRAPHING CHILDREN 182
VIEWS FROM MY WINDOW 194
ON TECHNIQUE 197

TO MY WIFE

IN THE BEGINNING

I was born in 1898 in Dirschau, West Prussia—now a part of Poland—where my father owned a department store. That seems infinitely long ago to me now, but perhaps photography and constant association with people younger than myself have kept me from feeling older than I should.

In 1906 we moved to Berlin, where I spent the rest of my boyhood and attended the Hohenzollern Gymnasium and the University. We were well off and lived quite comfortably in a large apartment. For me it was a relatively calm and stable period. I don't remember having any interest in political affairs, although I do recall seeing the Kaiser on horseback during a parade. To the best of my recollection I wasn't an unusual child. I had one brother who was younger but stronger than I; he liked to box and chase me around. Later, I got strong enough to get the best of him. But nature never intended me to be large—I stopped growing at the height of five feet and four inches.

Perhaps I might have become a musician. I was fond of music and played an instrument—but with my feet, not my hands. An aunt of mine owned a mechanical piano, the kind you worked by pumping the foot pedal. She had only two or three paper rolls of music, as I remember. One was the Piano Concerto in A Minor by Grieg, which I played time and time again. However, that was about the extent of my musical career.

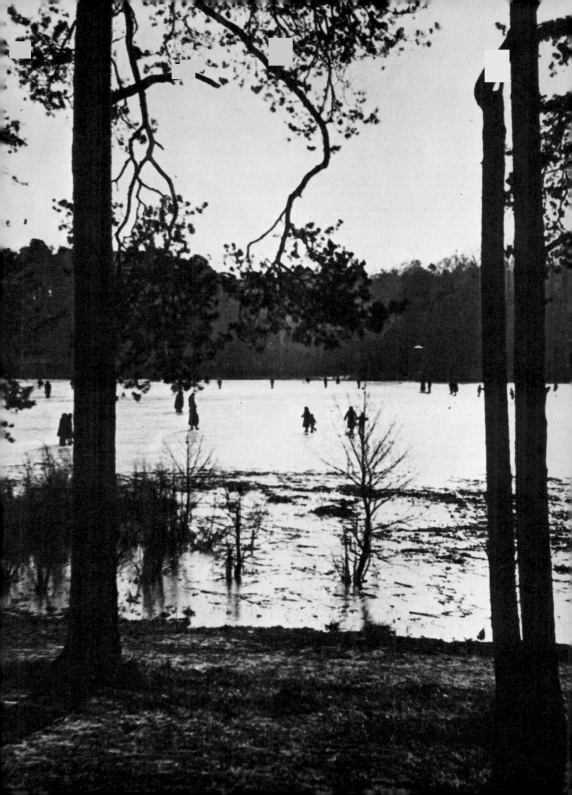

My first encounter with photography wasn't much more promising. On my fourteenth birthday an uncle gave me an Eastman #3 camera—a simple folding type. I used it for a while and learned how to develop film in the bathroom of our apartment. But like so many boys in their early teens I had a rather limited attention span and soon lost interest in this hobby. If anybody at the time had predicted that photography would become my life work I would not have believed it. At left is one of my first photographs—a winter scene near Berlin in 1913—taken with a simple folding camera when I was about fifteen.

World War I came, and in 1916 I was drafted into the German army. I was seventeen. After about six months' training I was shipped off to Flanders where I served as a field artillery cannoneer from 1917 to 1918. My military career ended on April 12, 1918, while my unit was trying to repel an Allied offensive near the village of Nieppe. I was firing my field gun when a British shell exploded about fifty feet overhead. Shrapnel hit me in both legs. It was exactly four-fifteen p.m.—I remember looking at my wrist watch as I fell off my gun. I was lucky. Nobody else in the battery survived.

My legs were saved, but for a long time I had to hobble about on crutches, then on canes. I was sent to a camp where I spent most of my waking hours learning how to salute officers properly. Finally the war was over, and, to my great relief, I was discharged.

The next years were hard for my family, as indeed they were for most Germans. We lost our money through inflation. I searched for a job to try to help out. The only work I could find was very dull—selling belts and buttons for a wholesaler in Berlin. I never was a good salesman, but the occupation did provide some income. I was much more interested in the arts, and loved to visit the museums of Berlin. Photography was in the air in Germany after World War I, and I became interested in it again. There were amateurs everywhere—and I became one of them.

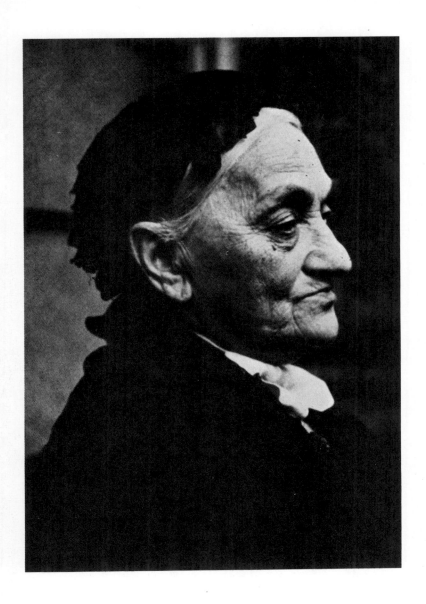

I made this portrait of my grandmother in 1920, shortly after I took up photography as a hobby for the second time. By 1926, I was a fanatical camera bug, working in a pictorial style, but with no idea that you could make a living from photography. At right is a street scene in Prague, photographed during that year.

10

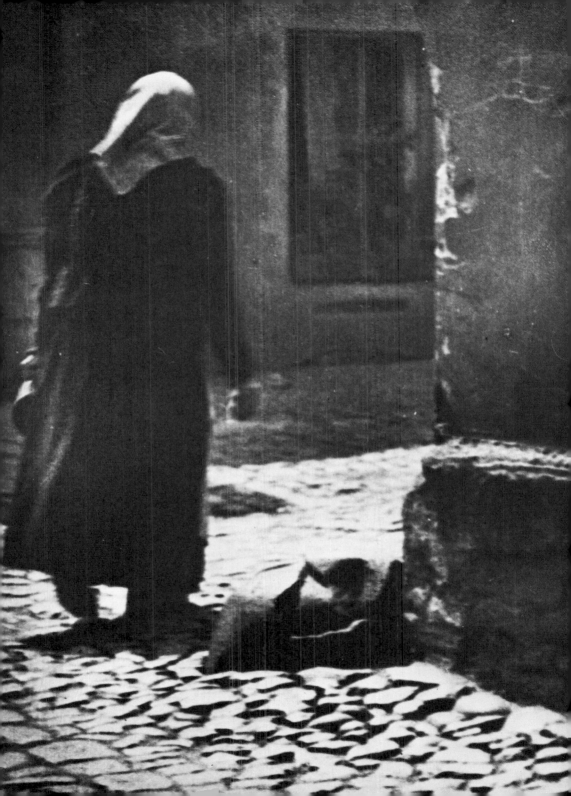

I SELL MY FIRST PICTURE: The photography bug really bit me in 1925. At the time, I owned a Zeiss Ideal camera with an $f/4.5$ lens, a folding type that used 9- by 12-cm glass plates. Until then I only knew how to make contact prints on printing-out paper. But in 1925—a most important year in my life—a photographer friend showed me how to make enlargements.

Enlarging—it was wonderful! You could crop out a face, a hand, a detail. For the first time I began to see the potentialities and possibilities of photography.

I became a real fanatic. I set up a darkroom in the family bathroom, using very primitive equipment—a wooden enlarger and papier-mâché trays. I didn't go to beer halls and I didn't eat lunch with my colleagues; I saved all my money to buy photographic equipment On weekends I went to the parks and woods of Berlin to photograph spider webs wet with dew, or the sun shining through trees.

I was mostly a pictorialist then, influenced by Rembrandt, Rubens, Degas, and other painters. I loved nature, and toned my prints sepia. I suppose I always have remained something of a pictorialist, especially in the photographs I make for my own pleasure. By my definition, a pictorialist is one who seeks visual beauty even in subjects that seem to have no beauty. To that I would add: A pictorial photograph is one that's beautiful but which you can't sell.

I didn't photograph nature only. I pointed my camera at everything in sight. In September 1927, on vacation in Czechoslovakia, I photographed some tennis players in the late afternoon sun. I liked the play of light and the long shadows. When I first printed the picture, showing the whole court, I was disappointed, so I enlarged just a portion of it, including only one figure and shadow. That made it.

I brought the picture to a camera magazine, *Der Photo Freund,* and showed it to the editor. He suggested I take it to *Der Welt Spiegel,* an illustrated weekly edition of the *Berliner Tageblatt.* The editor there said, "We'll buy it for twelve marks fifty." I was astonished. It seemed like an enormous sum to me. I'll never forget what I said: "You mean you can make *money* with pictures?"

They published the picture as a back-of-the-book feature with the title, "Autumn, the Shadows Grow Longer," and they asked for more. That was good news for me. I became more of a camera fanatic than ever.

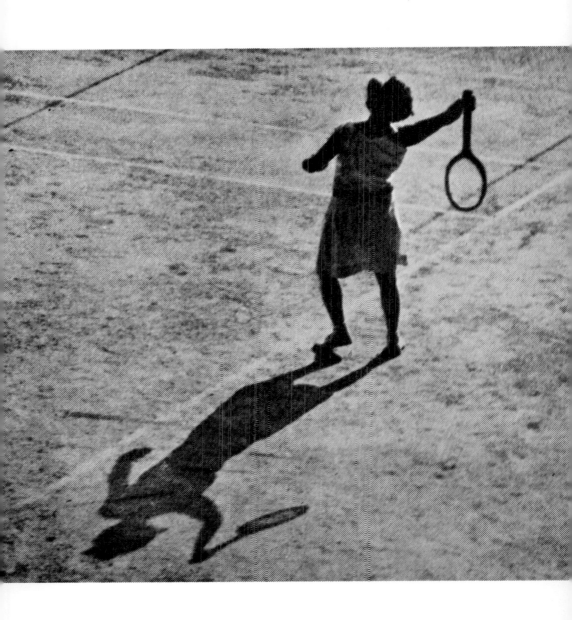

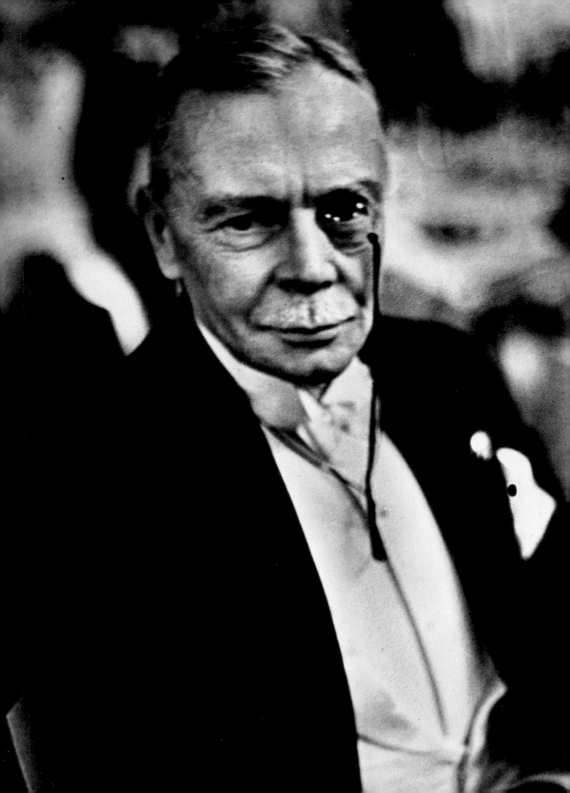

EARLY AVAILABLE-LIGHT PHOTOGRAPHY: Modern photojournalism was invented in Germany by a handful of editors and photographers in the late twenties and early thirties. It was my good fortune to become involved with this exciting new phase of camera reportage, although I wasn't really aware of the significance of it at the time. I kept my job as a button-and-belt salesman, but more and more my energies were devoted to photography. I sold a number of pictures and made a fifty-fifty arrangement with the Pacific and Atlantic Picture Agency (soon to be absorbed by the Associated Press). I also established useful contacts with Ullstein, publisher of a number of lavishly illustrated magazines.

I soon learned one thing—you couldn't earn much money just taking "pretty" pictures. Reportage of important events and people sold much better. It was a new kind of picture reporting, though. Instead of posed, flashbulb pictures, editors wanted candid photographs taken only by the light existing in the scene. Perhaps the most famous photoreporter in those days (and now almost forgotten for this phase of his work) was Martin Munkacsi. He used a 9- by 12-cm reflex camera and was the "in" photographer. Also making a name for himself with unposed available-light pictures of politicians, statesmen, and other celebrities was Dr. Erich Salomon, who used an Ermanox.

One of the people who had a strong influence on my early career was the editor of *Weltspiegel.* "If you really want to get ahead as a photographer," he said, "you should do the type of photography Dr. Salomon does." I already had taken a step forward in terms of camera equipment, replacing my Zeiss Ideal folding camera with a Plaubel Makina. I was very proud of this press camera, but I decided I also needed an Ermanox if I hoped to take pictures like Salomon. I bought one in 1928.

The Ermanox is a legendary camera. It had an $f/1.8$ lens—fantastically fast for its day—which opened up a whole new style of photography. Even with the relatively slow emulsions available then, the Ermanox made it possible to dispense with flash and to record people and events indoors with a realism heretofore unknown. I kept my Ermanox for many years. I wish now that I had never sold the camera—it would be a valuable collector's item.

One of the first things I did with my Ermanox was to visit the famous Sportpalast in Berlin where a seven-day bicycle race was being held. (The Sportpalast was soon to become better known as the meeting place where Hitler made some of his most important speeches.) I shot with the lens wide open at a slow shutter speed, having no idea whether anything would come out. One result is the photograph on pages 16 and 17. In retrospect I rather like the mood of the picture and the blur of the speeding bicycles. I assure you, though, the effect wasn't deliberate.

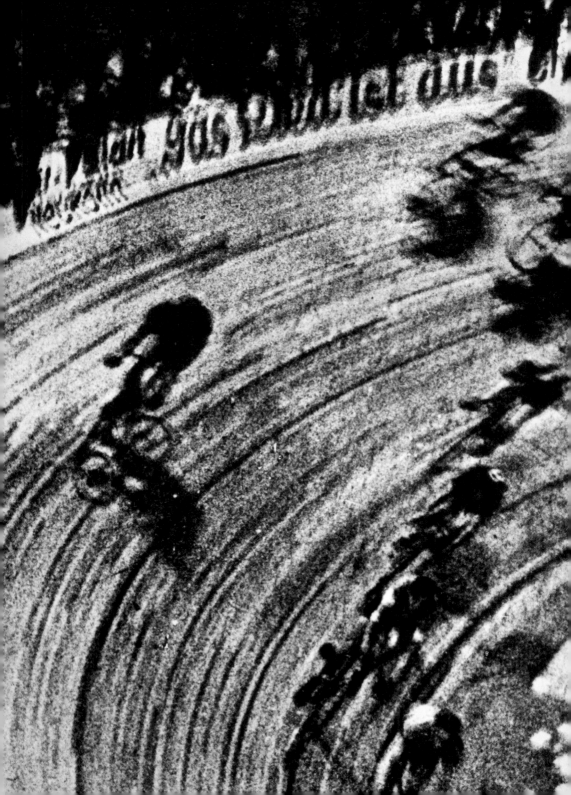

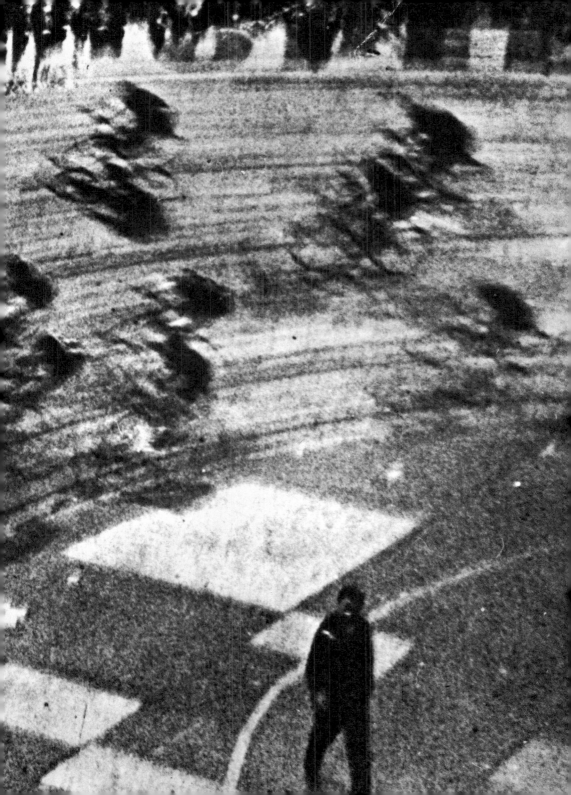

A little later I got my first assignment with the Ermanox: to photograph a mass meeting of the Salvation Army in a large hall in Berlin. This subject was a radical departure from the pictorial type of camera work I'd been doing and is my first real piece of reportage.

I set my camera up on a tripod and photographed the crowd, the speeches, the singing. At one point in the program, the leader said, "Let us pray." Everybody knelt—and I made an exposure. It turned out to be the best photograph of the set (page 19).

The Ermanox was a remarkable camera, but it also was remarkably difficult to use. As I look back on things, it's incredible what we had to go through to get a picture in those days. Photographers are princes today, by comparison.

The picture of General Hans von Seeckt on page 14 is a good example of my style and working methods with an Ermanox during those primitive days of available-light reportage. I took that picture at a ball attended by many notables. The lighting was good, fortunately, but I had to use a tripod—as I did for practically every picture I made with the Ermanox. The General was seated at a table. Visualize in your mind the procedure:

You approach with camera and tripod, ask permission to photograph, and set up. First, you must focus through the camera's ground-glass back, using a small pocket magnifier. Then, put in the metal plate holder with its glass plate, and remove the slide. Next you have to watch very closely. "Look this way, General!" Click-click—about a half-second exposure. You must be extremely careful not to catch him while he's moving. Replace the slide, remove the plate and holder. *One* shot. You want another? Then you must repeat the whole procedure. Needless to say, we didn't tend to overshoot in those days. In looking back, I'm amazed we were able to get the "candid" results we did.

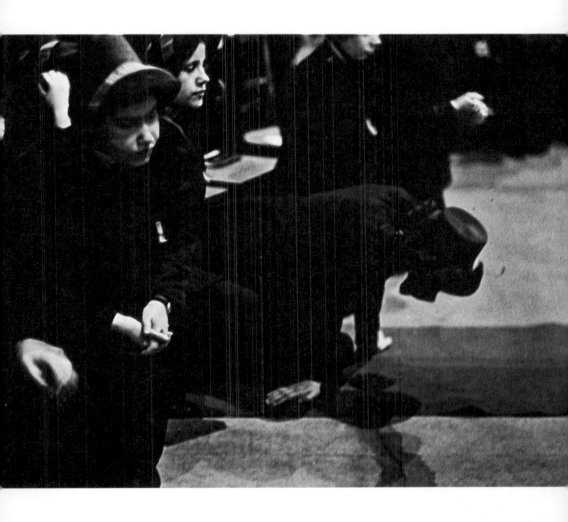

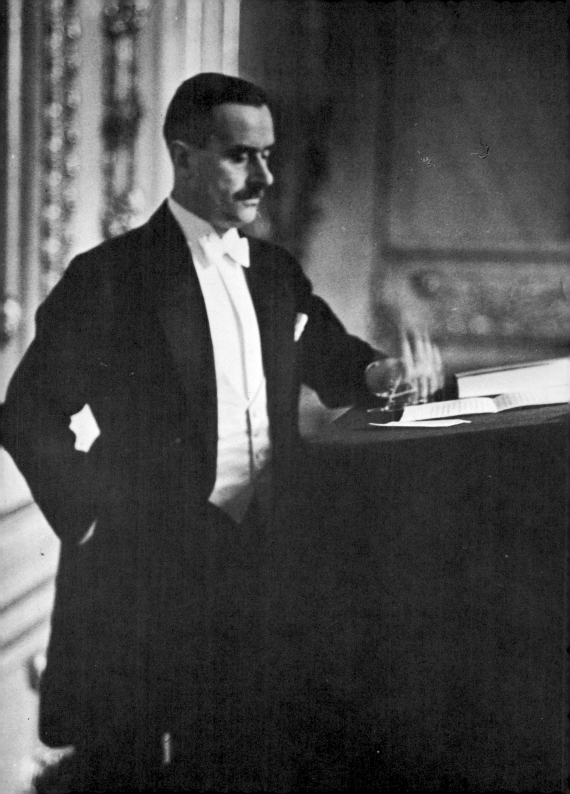

HOW I BECAME A PROFESSIONAL

The year 1929 was a decisive one for me. My work as a free-lance photographer began to pay better money than I was making as a button-and-belt salesman—to say nothing of being much more interesting. My employer knew about my extra activities, and late in 1929 he called me in and said, "Mr. Eisenstaedt, you have to make up your mind—be a salesman or be a photographer."

I told him I'd think about it. By this time I'd acquired a degree of self-confidence in my photographic abilities. Also, I was a very bad salesman; I wasn't selling many buttons and belts anyway. Therefore, I decided to make the break and become a full-time professional photographer. When I made my decision known to my employer, he looked at me with great pity and said, "You know, I think you've dug your own grave."

Actually, it didn't work out quite that badly. Within a few days after quitting my job I had an assignment from the Associated Press (it had acquired the Pacific and Atlantic Picture Agency with which I already had an arrangement). I was on my way by train to Stockholm to photograph Thomas Mann, who was to receive the Nobel Prize in Literature that winter for *Buddenbrooks*.

I remember this assignment, my very first one as a professional, very vividly. It was done for a large radio-broadcasting magazine, *Die Funkstunde*—you might call it the *TV Guide* of its age. I traveled with my Ermanox and many pounds of metal holders and glass plates, and I was very excited about the whole project.

I covered the ceremonies during which Thomas Mann received the Prize. Afterward, he gave a lecture in an adjoining room to a smaller crowd. I had made arrangements to photograph this, too. I got permission to be there after promising that I would use no flash and that everything would be very unobtrusive and noiseless. The photograph of Mann on the opposite page is a result of that coverage—it was taken at four p.m. on December 9, 1929, by existing room light with my Ermanox.

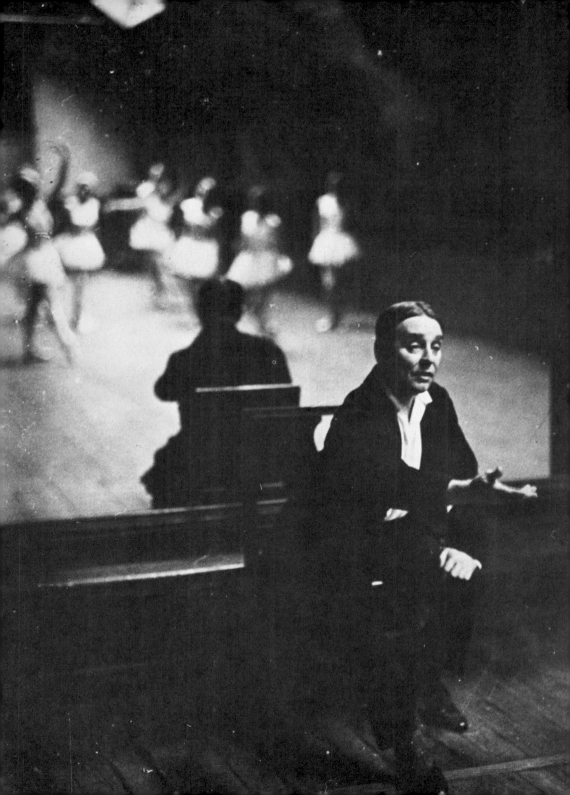

Despite the technical difficulties, those were, in one sense, "the good old days"—you had no competition. I was the only photographer there, I believe. If a photographer is left alone, he can do anything. As soon as there are two of you photographing the same subject, things become much more difficult.

I developed the film myself, later that evening, in my hotel room. I was using Ilford-Zenith glass plates, rated at H/D 700—about the equivalent of ASA 32. They had a green antihalation backing that came off in the developer and turned it black. Terribly dirty and messy to work with, but I was delighted that the pictures had turned out.

The editors were pleased, too, and I continued to get assignments covering celebrities and political events. All this was good training for a photojournalist, but the assignments I enjoyed the most were the ones that gave me freedom to try a more pictorial kind of picture.

One assignment of this type took me to France in 1930, where I covered the ballet training school of the Grand Opéra de Paris. These were my first ballet pictures. It is a favorite subject of mine and I've photographed ballet many times since, but I still like these early attempts very much. (See opposite and overleaf.) I had the chance to indulge myself in the Rembrandt-like lighting I liked. I made these photographs with my Plaubel Makina, rather than the Ermanox, because I could see and compose more carefully on the larger ground-glass back of the former. They were taken at about 1/10 second with my camera on a tripod.

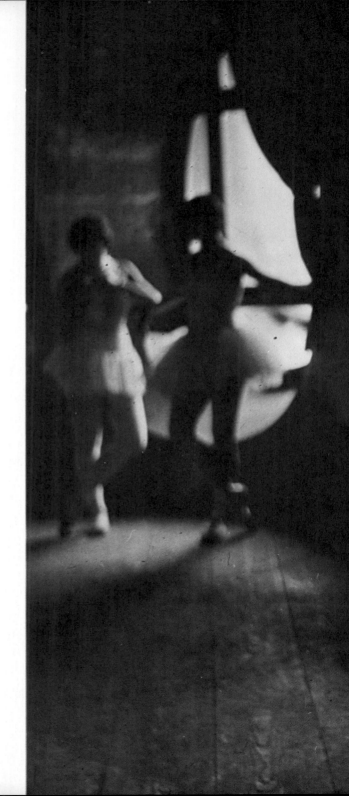

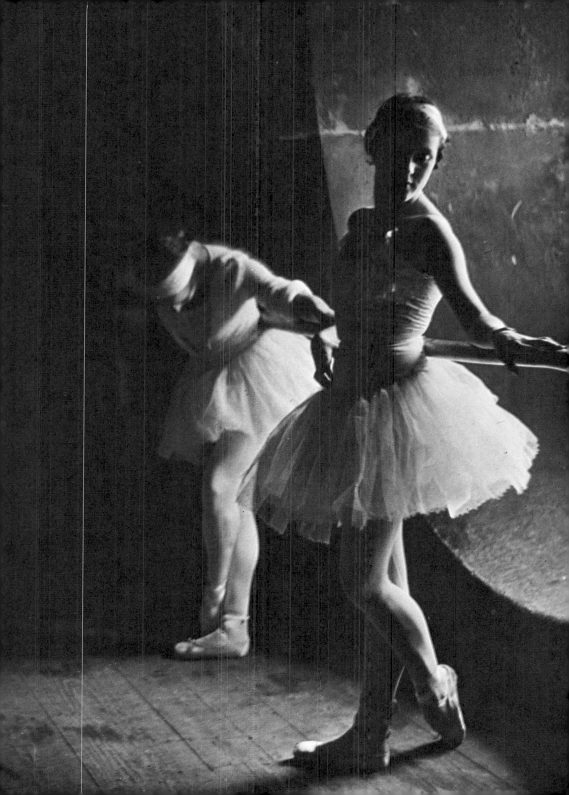

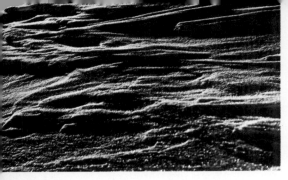

"SNOW THAT LOOKS LIKE SUGAR": Although making my living at photography, I was still only a jump ahead of being an amateur. There was much I had to learn—most of it the hard way.

One of the people who inspired me was Dr. Erich Salomon, I very much admired the type of photographs he took, and he was a gentleman. We often worked side by side on political assignments.

One of the things I learned was that clothes help make the photographer. We had tails and dinner jackets, and being properly attired made a world of difference. We were accepted and admitted to places where we otherwise never could have gone.

Our formal clothes were specially tailored with reinforced pockets for the heavy metal holders and glass plates we used. I learned to follow an unvarying routine in this respect—unexposed film in my left pocket, exposed in my right so I couldn't make a mistake.

I also learned more about how to approach an assignment. In the winter of 1930, Kurt Korff, the influential and picture-minded editor of Ullstein's *Die Dame,* asked me to go to St. Moritz, Switzerland, where the winter sports and social season was at its peak. This very general, open assignment worried me. "What shall I do?" I asked him.

"Photograph snow that looks like sugar," he told me. "If you come back with just that one picture, the trip is worthwhile."

Well, it was an answer, although not a very satisfactory one. Just once, after going up a ski lift I found a drift with the light slanting across it—snow that looked like sugar. (See above.) In the meantime, I'd loosened up and was seeing all kinds of wonderful things to photograph.

I was learning to "see fast" and to respond quickly. I was sharpening the speed of my reflexes. One of the non-snow photographs I took was a view of the ballroom in the Grand Hotel, made at the top of stairs leading down to the dance floor. (See opposite.) Again, I used my Ermanox on a tripod. No exposure meter—you just had to guess. If the light was poor you went "Click . . . click." If it was good, "Click-click." Crude, but it worked.

26

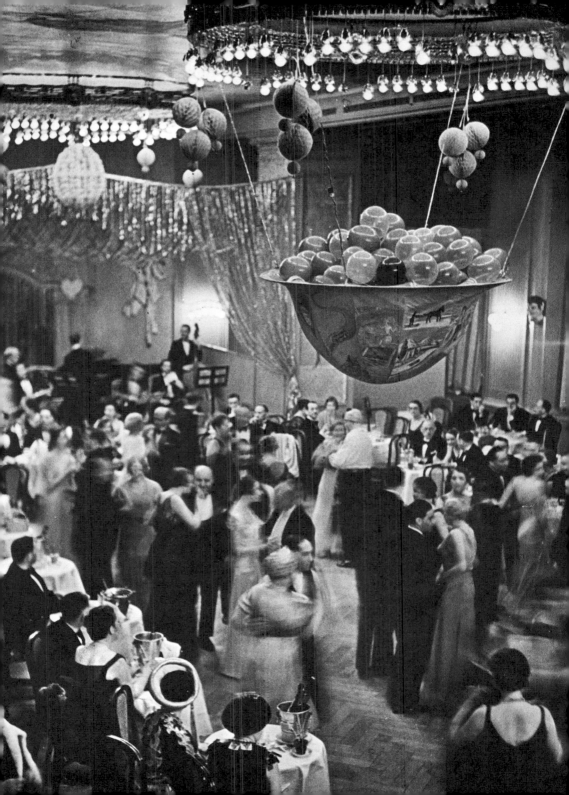

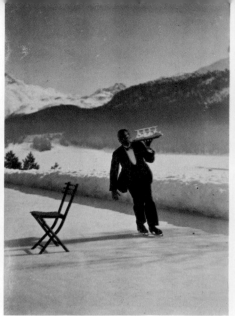

ACTION AT ST. MORITZ: Going to St. Moritz in the winter became a regular assignment. The pictures on these two pages were taken at the Grand Hotel, where there was a famous ice-skating rink and restaurant. A big attraction was the waiters on skates. One day there was a class for new waiters, and naturally this seemed like an interesting subject.

An over-all view of the activity didn't look like much, as you can see from the picture at left above, a contact print from the glass plate. I was using a recently acquired 9- by 12-cm Zeiss Mirroflex camera. The headwaiter, a superb skater, wore black tails and tie, a nice contrast against the whiteness of the ice and the snow-covered Alps.

The sunlight was dazzling and I was able to shoot at 1/500 second to stop the action sharply. The problem was how to focus on a fast-moving subject. My camera had no rangefinder. I had to focus through the ground-glass back, insert the plate, and then take the picture. I put a chair on the ice as a stationary target point, prefocused on it, and had the waiter skate past.

It took a few tries: the second picture just doesn't have enough action. Finally, in the picture opposite, I hit it just right, with the man's arm and leg extended and his tray tipped, the glasses and bottle seeming to defy gravity. Cropped in tight, it makes a strong picture

Of course it's much easier today to shoot action with fast-working rangefinder cameras, but I still find the old trick of prefocusing on a target point is useful.

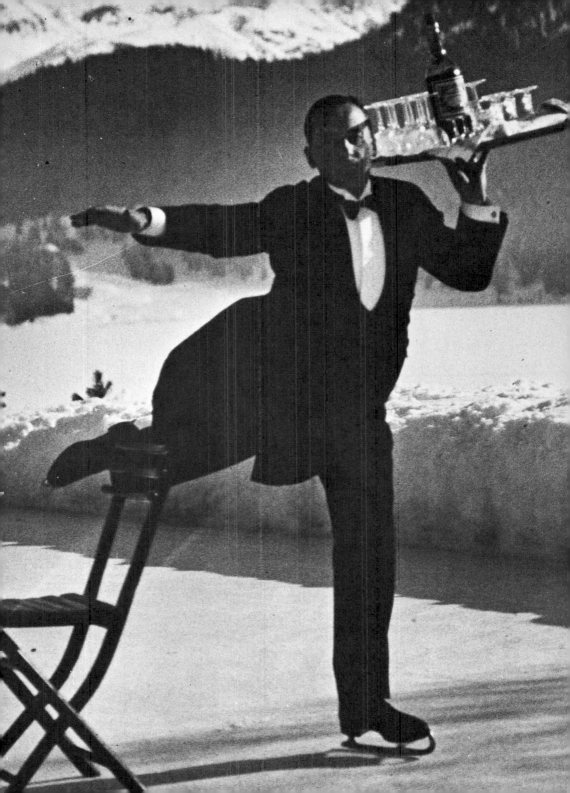

I DISCOVER THE LEICA: The greatest disadvantage of the cameras I was using in 1929 and 1930 was the time lost between shots. Even the Ermanox, with its relatively fast lens, was a one-shot camera, and the heavy metal holders and glass plates were an unbelievable nuisance.

The answer was the Leica, the first 35-mm still camera. Not only did it have a fast lens, it let you take thirty-six exposures without reloading. Oskar Barnack of Leitz had built the first model before the war for making exposure tests with movie film. To his surprise, it turned out very good still pictures. It appeared on the market in 1926. I discovered its potentialities about four years later when I was covering a disarmament conference at Lausanne. Another photographer was there, an acquaintance—a very elegant, lazy man. He had only a little Leica, one lens, and a small folding tripod. We were sitting in a café, when a marching band of children came by. They were dressed in splendid uniforms, like generals.

My friend said, "Gee, this is terrific, but I don't feel like chasing after them. Do you want to do it? Here—take my camera."

He quickly showed me how it worked. I ran after the band and shot picture after picture. It was great. Afterward some of the pictures were published—under my friend's name, but I didn't care. I was too excited. "This is some camera," I told myself. "You have to have one." Soon I was using a Leica for just about all my work.

One of my early 35-mm picture stories was a series of candid street scenes of the poor people of les Halles, in Paris—the workers, prostitutes, and beggars who lived there. (A few examples are reproduced on the next three pages.) The negatives are badly scratched now, but I'm still very fond of this set.

It was much easier to take candid pictures then. If you had a small camera, nobody even realized you were a photographer Well, almost nobody. The woman in the black boots (page 32) noticed me and didn't like it at all. She whistled, and suddenly a number of people came running out of nearby buildings. Some of the men had knives. I think they might have killed me if they'd caught me, but fortunately I could run pretty fast.

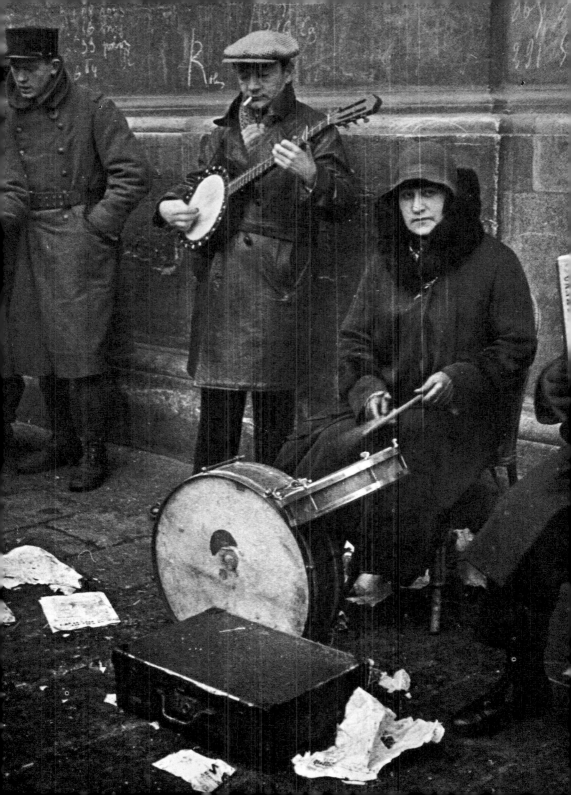

LEARNING TO BE A PHOTOJOURNALIST

During the early and mid-1930s I was kept very busy on assignments. I remained a free-lance photographer, but continued my connection with the Associated Press. My photographs were in a number of European picture publications, including Ullstein's *Die Dame* and *Berliner Illustrated,* the *Graphic,* and the *London Illustrated News*—the prototypes of our contemporary picture magazines. (A selection of this early photojournalistic work is shown on the accompanying pages.)

It was a time of training and experimenting, of trial and error, of making mistakes and learning the fundamentals of photoreportage. I did make mistakes, too. Perhaps my most spectacular failure—which almost nipped my career in the bud—took place in 1930 when the Associated Press sent me to cover the wedding of King Boris of Bulgaria and an Italian princess. I carried about three hundred pounds of camera gear (mostly metal holders and glass plates) to Assisi in Italy, where the ceremony was to take place. It was my first trip to Italy, and I was very excited. I got carried away with the pageantry and color of the wedding. I photographed like mad: street scenes, the crowds, choir boys, the church, the wedding guests, everything—everything but the bride and groom!

When I returned and the editor in London found out I'd missed getting the key picture, he was pretty angry. "This man has to be fired immediately," he said. I can't say that I blamed him. Fortunately, however, they couldn't fire me because I wasn't on salary. It all blew over, and I got more assignments. But thereafter I was careful to make sure I always came back with pictures of my subject.

Some of my assignments involved famous people. For instance, I photographed George Bernard Shaw in his home at Whitehall Court in London (opposite). This was in 1932. I used the Ermanox here, mainly because I wanted to focus and compose on the ground glass. He was an enthusiastic amateur photographer himself and I didn't have to pose him much—he kept trying poses himself because he thought they "might be interesting."

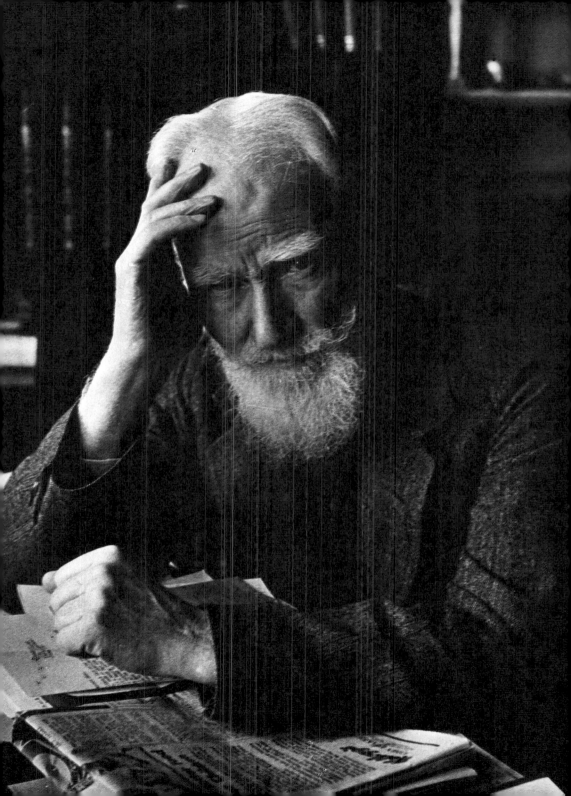

Other assignments involved more humble subjects, but I enjoyed them too. As a photojournalist, you must not be conceited or choosy about your assignments. You learn something from every picture you take. The ideal attitude of a photojournalist is typified for me by my colleague at *Life,* Margaret Bourke-White. At the peak of her distinguished career she was as willing and eager as any beginner on a first assignment. She would get up at daybreak to photograph a bread crumb, if necessary. If you ever lose this kind of interest and enthusiasm, you might as well say good-by to photography.

Everywhere I went I learned to look at things with a photojournalist's eye, to search for those aspects of my subject that were visually interesting, that told a story in a strong, pictorial way. And I found them everywhere, too: a woman in native costume pushing a baby carriage at the top of a dike in Holland (opposite), an elderly man at a retirement home in Italy (page 38), a priest on the steps of Milan Cathedral (page 39). These years of varied assignments were good discipline for me and helped train my seeing as a photojournalist.

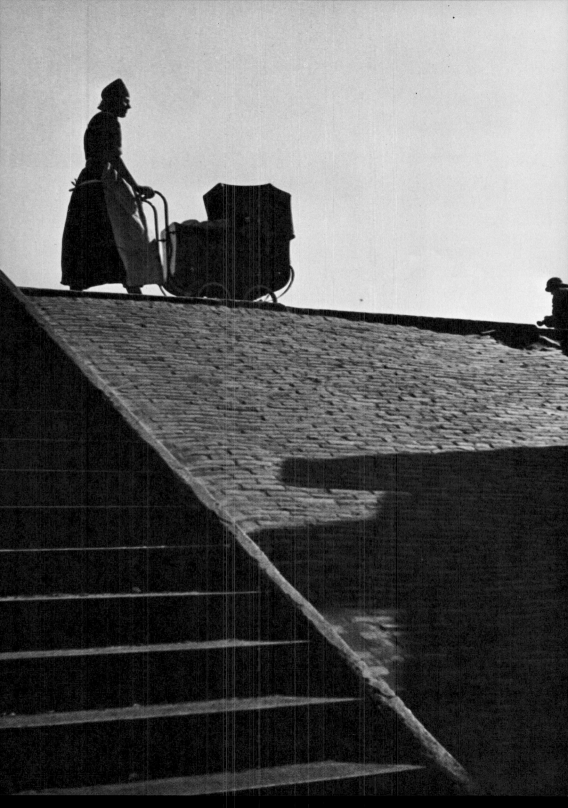

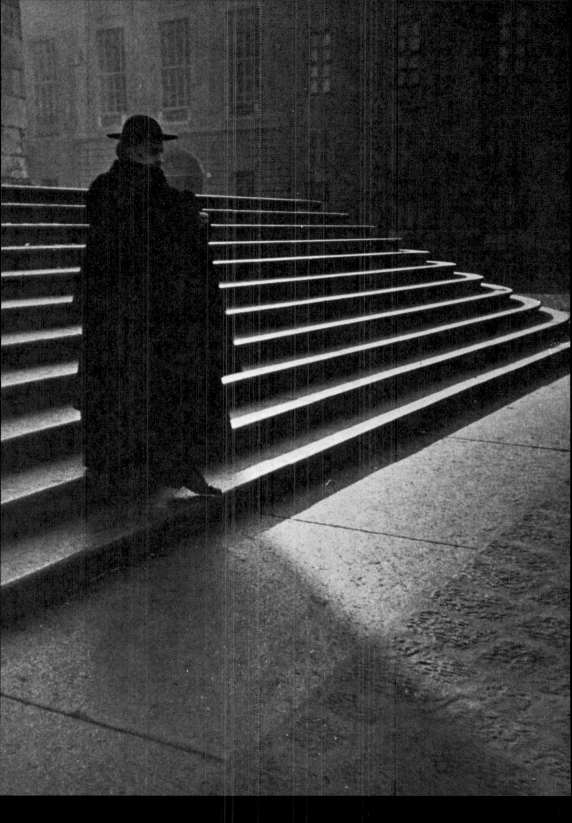

A LONG-AGO EVENING AT THE OPERA: The photograph opposite is one of my best-known pictures, one I like very much. It caused something of a sensation when I made it in 1933: it was published all over the world and has since appeared in many books and exhibitions.

It was taken in La Scala Opera House in Milan, at the première of Rimsky-Korsakov's *The Invisible City of Kitezh*. I'd photographed backstage, in the costume and prop departments, and at the prompter's box during rehearsals. On the night of the performance I concentrated on capturing the atmosphere of the event. During an intermission I went up to one of the boxes with my Leica and a 35-mm lens to give me a wide-angle view.

The only light used was the existing illumination. I had no exposure meter (didn't yet own one). My camera was on an inexpensive and rather unsteady tripod, and my exposures were running about a half a second.

First I shot straight across at the boxes on the far side. This gave a strong design with bands of light and dark, it was too flat, too remote, with no important detail to catch your eye or tell the story. I looked around for something interesting for the foreground, and my great luck was to find this lovely girl with her opera glasses. I focused very quickly and took four shots. The best is the second frame; her full face is turned toward her companion but not hidden by the program. The girl makes the picture. Without her it would have been ordinary.

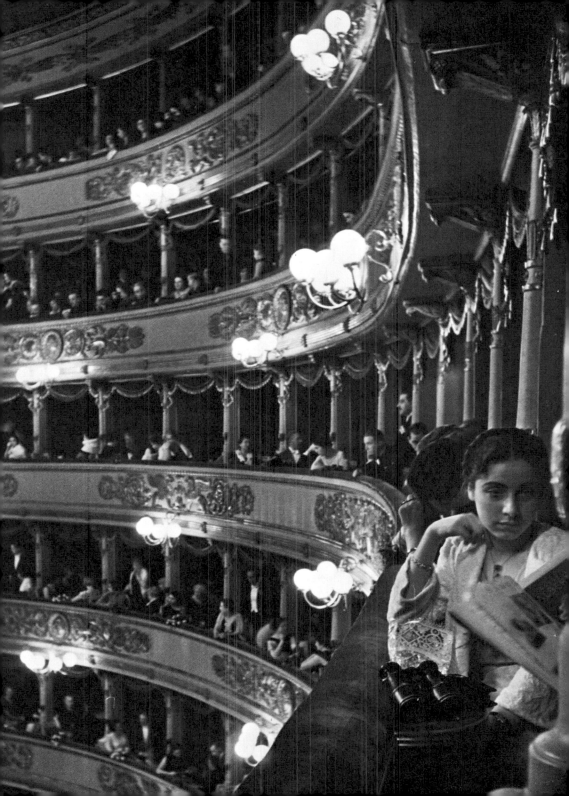

THE RISE OF THE THIRD REICH: For a photojournalist, the early thirties were momentous years, and I covered many disturbing revolutionary political events.

In 1933, half a year after Hitler took power in Germany, I was assigned to cover the fifteenth League of Nations Assembly in Geneva. Paul Goebbels, Hitler's minister of propaganda, was one of the key personalities there, and it was necessary that I come back with strong photographs of him.

I found him sitting alone at a folding table on the lawn of the hotel. I photographed him from a distance (see below) without him being aware of it. As documentary reportage, the picture may have some value: it suggests his aloofness. But it wasn't the kind of "stopper" picture-minded publications were demanding.

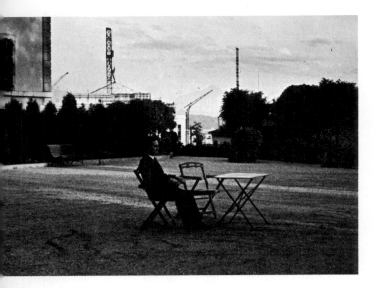

Later I found him at the same table, surrounded by aides and bodyguards. Goebbels seemed so small, while his bodyguards were huge. I walked up close and photographed Goebbels. It was horrible. He looked up at me with an expression full of hate. The result, however, was a much stronger photograph (opposite), which has often been reproduced since. There is no substitute for close personal contact and involvement with a subject, no matter how unpleasant it may be.

As a curious footnote, Goebbel's aides were very friendly. A number of them came up to my apartment in Berlin later. The visit made me somewhat nervous, but, like so many people who have been photographed, they were mainly interested in getting prints of the pictures. I gave them some, and they seemed very pleased.

42

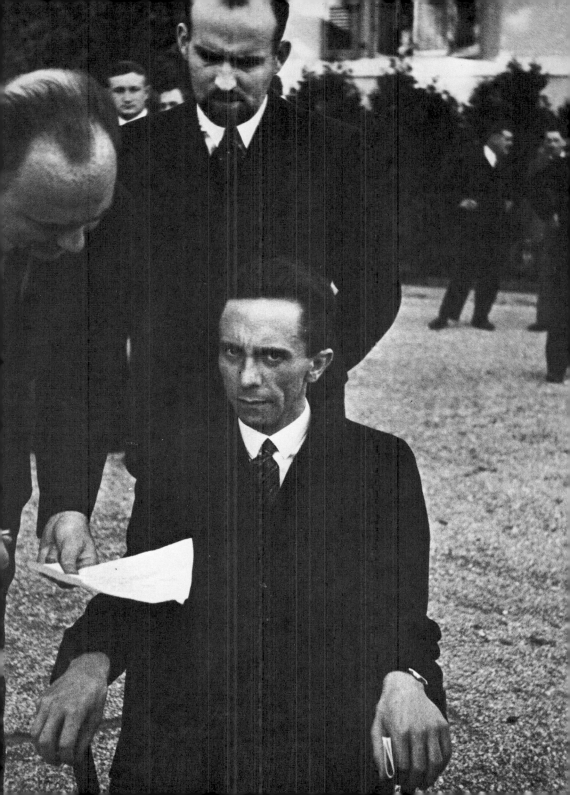

HINDENBURG'S FUNERAL: Another photograph which has a certain documentary value, as well as being an illustration of the handicaps under which one often must work, is this picture of Hermann Göring. I took it August 5, 1934, during funeral services in Tannenberg, East Prussia, for Field Marshal von Hindenburg, the President of Germany.

My possibilities of making good pictures were severely limited. I was on a special press stand with eight or ten other photographers. I knew that the light on the white hats of the naval troops would create a strong pattern, but I had no control over my viewpoint or events. About the only creative decision I could make was precisely when to trip the shutter—which I did as Göring passed, giving the Nazi salute. Again, at this stage in my career I was using the Leica, and I believe a 35-mm lens was employed here, to include more of the surrounding troops than a 50-mm lens would have given me.

LIGHTER THAN AIR: One of my most interesting assignments was a trans-Atlantic flight aboard the Graf Zeppelin. (If I'd suspected the ultimate fate of the aircraft, I might have been less exhilarated by the assignment.)

We encountered a storm over the Atlantic, and some damage was done to the hull. Escorted by a very nervous member of the crew I was allowed to climb up a ladder to a little hatch on the top of the huge craft to photograph the repair work.

"You may take three pictures," my escort told me. "Three pictures, that's all." So I opened the hatch, poked out my head, and shot—bang, bang, bang—like that. It was pure luck that the men formed a coherent, interesting design. In retrospect, the photograph (overleaf) has a futuristic look, like much more recent photographs of astronauts working on a satellite in space.

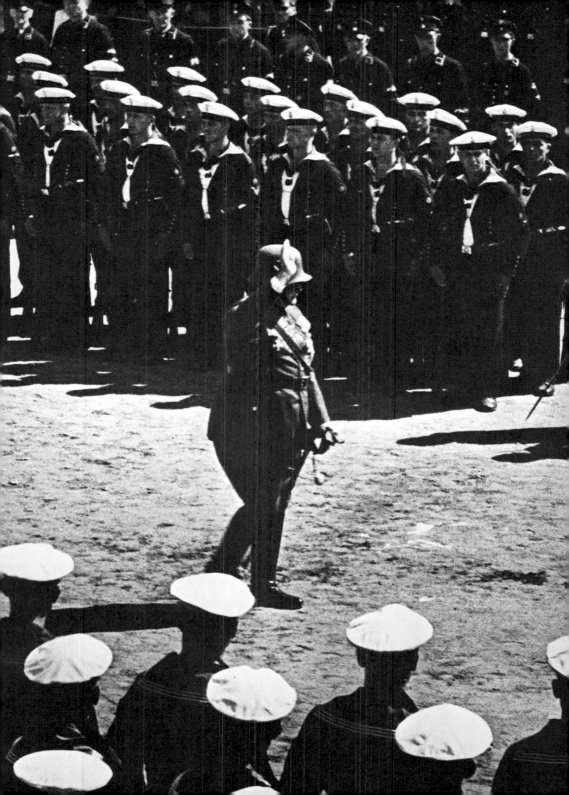

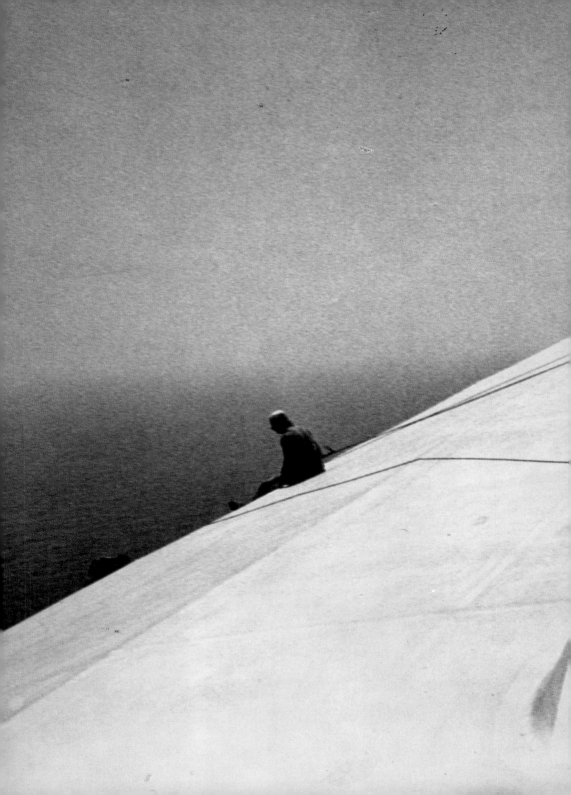

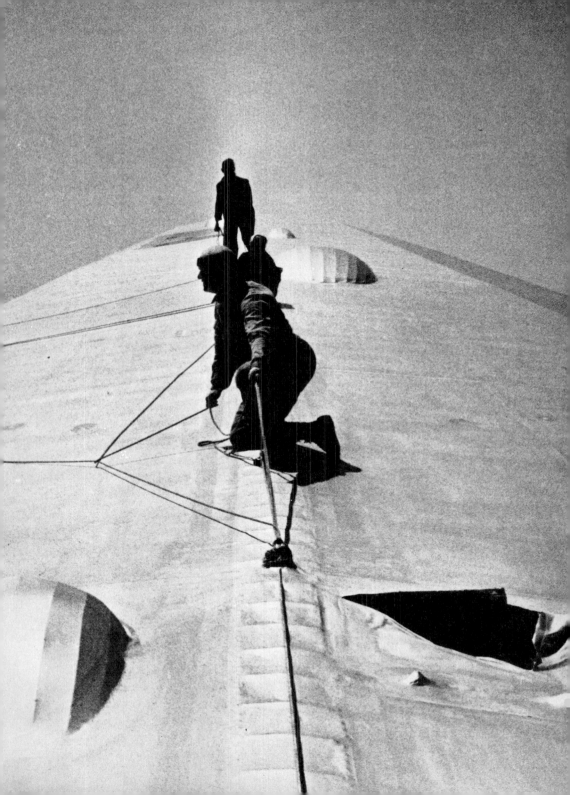

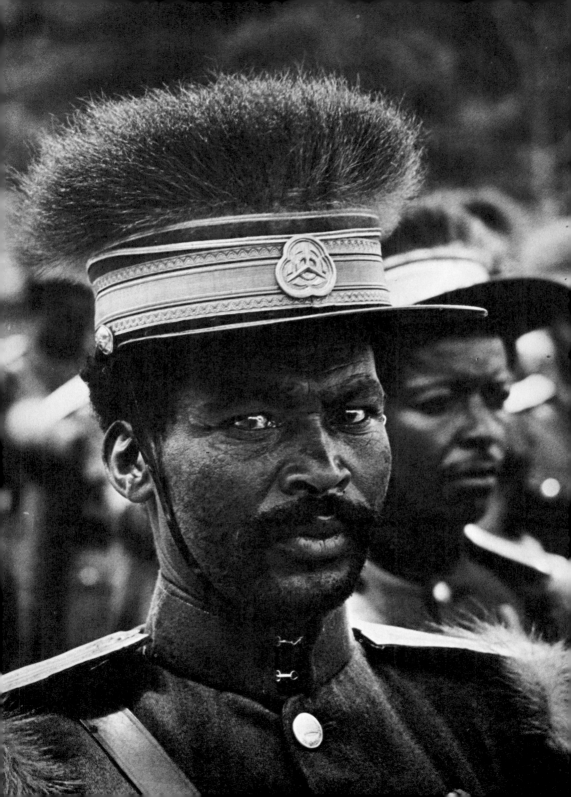

ETHIOPIA: In March 1935 I was assigned to visit Emperor Haile Selassie in his capital at Addis Ababa. This turned out to be one of the most important assignments in my entire career. I shot thousands of photographs showing many aspects of life in that primitive country. It was the most ambitious and complete coverage I'd ever attempted. I used my Leica with 35-mm, 50-mm, and 90-mm lenses.

Less than a year later, Italian troops invaded Ethiopia and there was a sudden and urgent need for background photographs. The pictures I had taken were in great demand. I can credit my Ethiopian coverage with helping to establish my international reputation as a photojournalist and making it possible for me to come to the United States and join the staff of *Life*.

The possibility of a war with Italy was very much in the air, and of course I spent considerable time in reporting the Ethiopian army and its primitive condition. By this time I had learned how to use my camera not just to find beauty, but to tell a story with visual images rather than words.

For example, I was fascinated by the wonderful faces of many of the soldiers I saw. They were old-timers, some of them, who had fought against the Italians before, at the Battle of Aduwa in 1904. I made many close-ups of these faces with the 90-mm lens, and they turned out to be among the most powerful pictures I took during this assignment.

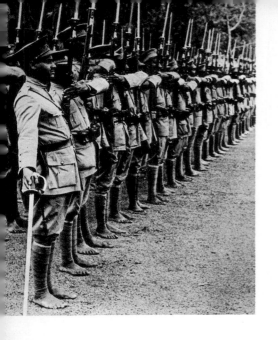

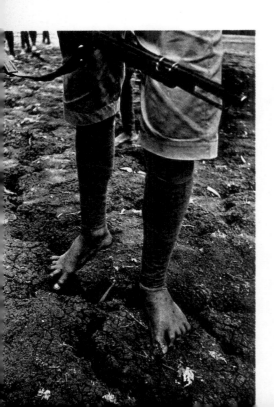

THE POWER OF THE CLOSE-UP: One of the discoveries I'd made, and which all good photojournalists must understand, is the power of a single detail to tell a story with great immediacy and impact. The three pictures reproduced here make the point clearly, I think.

The Ethiopian army was equipped in a very primitive manner and this, of course, was an important point to get across. I photographed rows of barefoot soldiers marching and at attention, as in the picture at upper left. Groups of soldiers make interesting visual patterns, and the idea that these particular soldiers are not equipped with modern arms comes across, but otherwise there is nothing very remarkable about the photograph.

Intrigued by the bare feet beneath the puttees, I moved in close to show the legs of a single soldier (lower left). This is a stronger, clearer visual statement, but it wasn't until I photographed the *soles* of a prone soldier's feet, caked with mud, in a tight close-up (opposite) that I got what I felt was the strongest statement. The soldier is not dead, as many people assume him to be; he is lying prone, firing a rifle. (The war itself didn't break out until months later.) However, I don't think this impairs the validity of the photograph. It shows a small but very significant detail which suggests much about the whole situation, the primitive condition of the Ethiopian army. The photograph certainly seems to be an unusually evocative one. It has been published many, many times, and once they have seen it, few people seem to forget it.

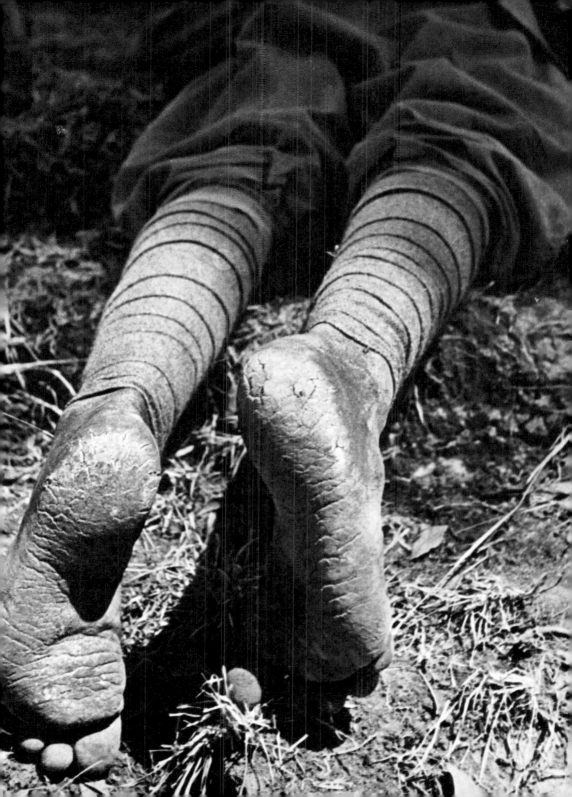

A COURT OF JUDGMENT: There is another sequence of photographs from my Ethiopian coverage that I think makes the point about how a photojournalist must learn to see. Looking at this sequence and studying it can tell you more than I can describe in words.

The scene was a public courtroom. I photographed the over-all scene (below) in what you might call a long shot, or establishing shot in motion-picture language. As a photojournalist, you accustom yourself to making photographs like this to establish the total scene. However, you don't stop there.

Next, I moved in to focus attention on the judges' table with its ornate covering and the wonderful faces behind it. (All the time, of course, I was working as unobtrusively as possible, shooting by available light. With flash, I never would have been allowed to photograph.)

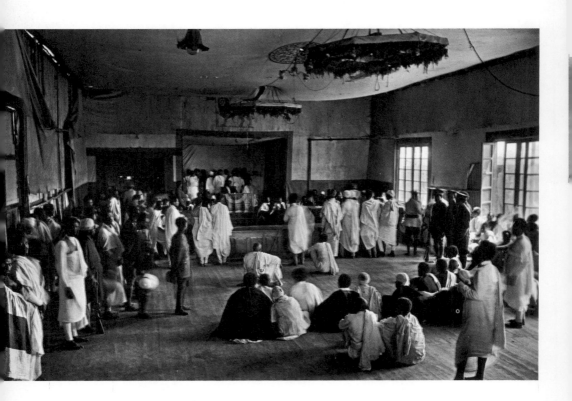

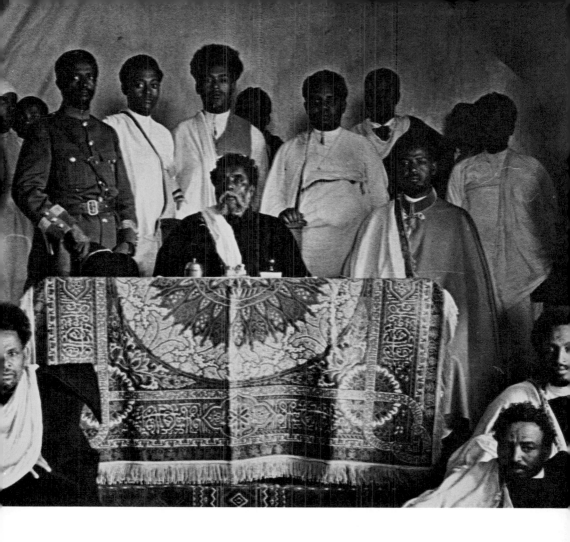

The strongest detail was the bearded face of the black-robed judge, so I moved closer yet, using a 90-mm lens. Now I felt I'd captured the essential drama of the proceedings in the expressions and stances of the handful of figures (overleaf). The way you print a photograph is most certainly one of the creative, interpretive techniques of photography. In this dark print, with the surrounding figures subdued and only the black-robed judge's face standing out clearly, I think I caught the powerful drama of the moment.

53

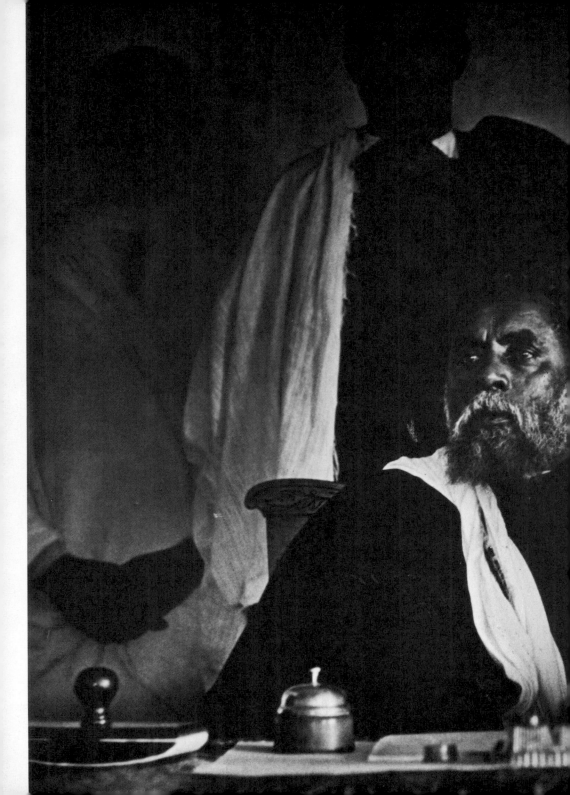

A SENSE OF TIMING

A photographer needs a short-circuit between his brain and his fingertips. Things happen: sometimes expected, more often unexpected. You must be ready to catch the right split second, because if you miss, the picture may be gone forever.

Fast reflexes are partly inborn, but they can be developed through practice and experience. You must know your equipment thoroughly, of course. You must be able to operate your camera quickly, automatically, without stopping to think. Life moves swiftly and unexpectedly; it won't wait for you to fumble with your focusing control or film advance.

On these pages are reproduced a number of my pictures where split-second timing was important. With some I've also included a few frames from the contact sheet, so you can see the near misses as well as the hits.

There's another element involved here, too, which I've already mentioned—luck. Often I think I've had more luck than brains as a photographer. The photograph on the facing page certainly is a good example of luck, as well as timing. I was walking through the crowds on V-J Day, looking for pictures. I noticed a sailor coming my way. He was grabbing every female he could find and kissing them all—young girls and old ladies alike. Then I noticed the nurse, standing in that enormous crowd. I focused on her, and just as I'd hoped, the sailor came along, grabbed the nurse, and bent down to kiss her. Now if this girl hadn't been a nurse, if she'd been dressed in dark clothes, I wouldn't have had a picture. The contrast between her white dress and the sailor's dark uniform gives the photograph its extra impact. Luck. But you do have to keep your eyes open, too!

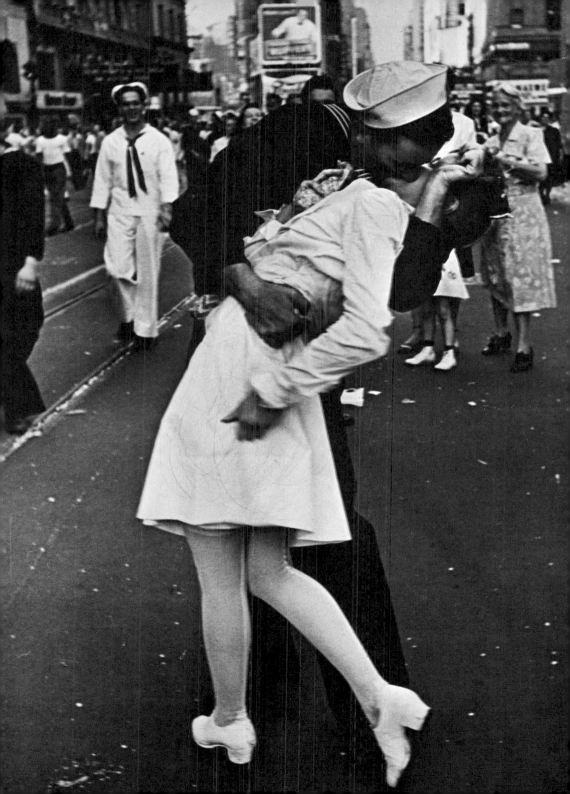

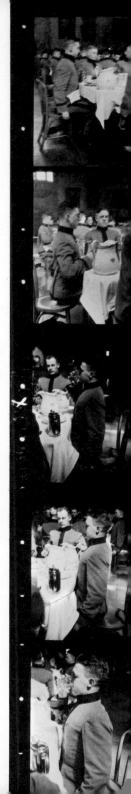

MY FIRST *Life* COVER: Shortly after I left Germany in 1935 and came to the United States, I was asked to join the staff of a new picture magazine that Henry R. Luce was starting. The magazine, of course, was *Life.* I joined the company in April 1936 and have been on its photographic staff ever since.

One of my first assignments was to do a picture essay on the military academy at West Point. The photograph of the cadet was selected as the cover for the second issue of *Life.* It's very much a "timing" kind of picture.

At West Point I naturally was very impressed by all the drilling, pageantry, and the hazing of the plebes. I was especially fascinated by the rituals of the dining hall, and the way they made the plebes eat sitting with a ramrod-stiff back.

I was lunching with a group of West Point officers, but excused myself and began shooting by available light with my Leica. The contact strip of four frames shows what I was doing: trying different angles and catching expressive moments. Frame No. 3 seemed to capture best the feeling of rigidity and discipline, and that's the one the editors chose for a cover.

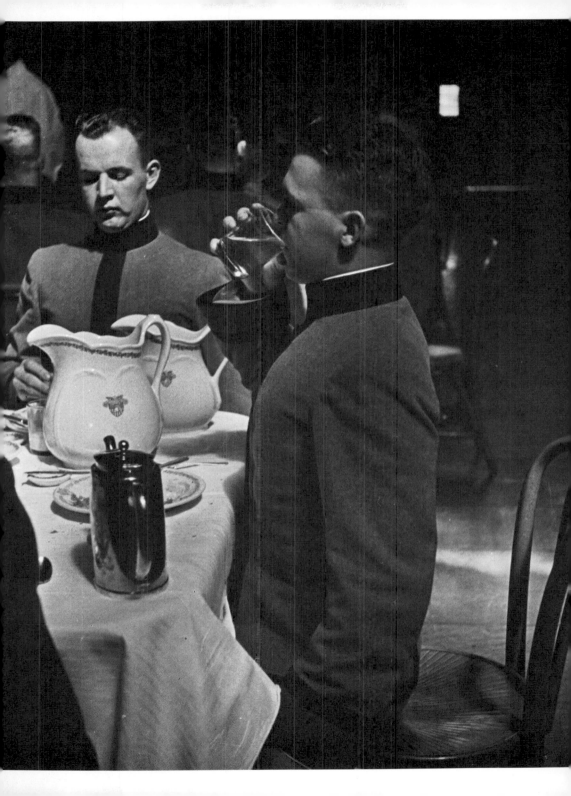

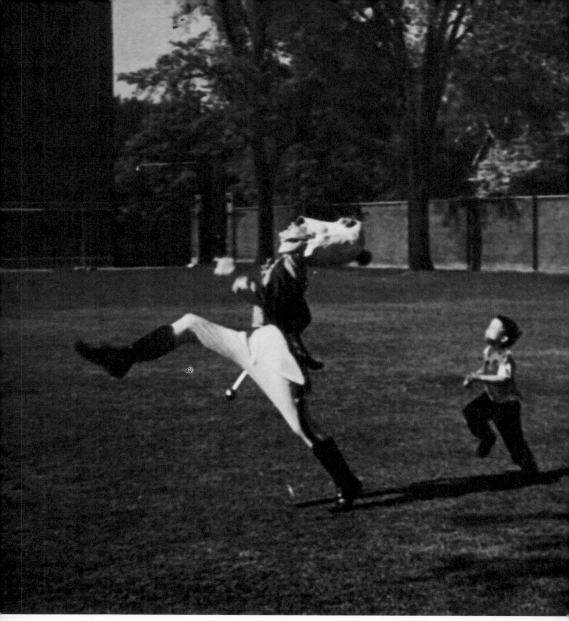

A DRUM MAJOR AND HIS MIMICS: People who see this picture often ask me if I posed it, and the answer is, "No, it just happened." I was at the University of Michigan at Ann Arbor in 1950, photographing the school's famous marching band. I covered all the usual things: the formations, the rehearsing, and so on. I was walking about the campus in the afternoon when I saw the drum major strutting along all alone (I

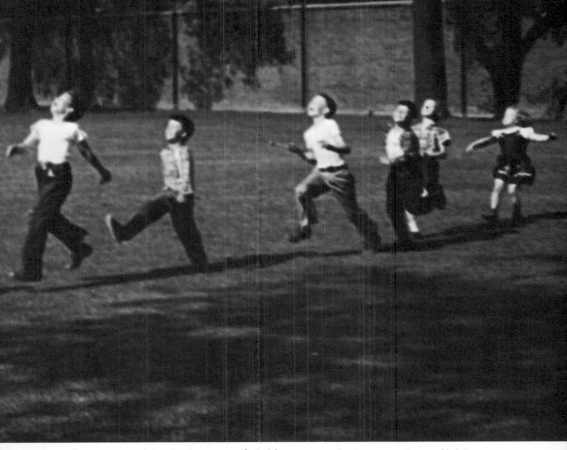

suppose he was practicing). A group of children were playing near the wall. They saw him, too, and all of a sudden they ran out and began to mimic him. It happened so very quickly I barely had time to focus, but I think it turned out to be the best, and certainly the most amusing, picture of the entire assignment. The moral is, you have to be there. If you're there—and react fast enough—it's okay.

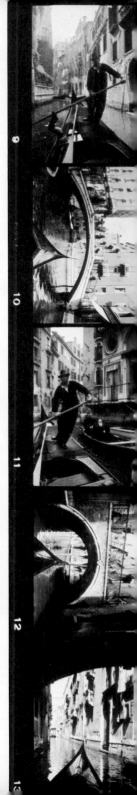

A VENETIAN GONDOLIER: These photographs were made in Italy in 1947, while I was on assignment covering post-war life in that country. After doing a lot of photography in Venice I decided to treat myself to a gondola ride, and took along my Leica with a 35-mm lens and Plus-X film.

The frames marked 9, 10, and 11 tell the story. In 9, I shot toward the stern, because I liked the bold figure of the gondolier in the foreground. The background is routine, however, and it isn't much of a picture. Next, in 10, I shot forward, including the prow of the gondola as we approached a little bridge. Again, nothing too exciting. Then I saw another boat coming—with two monks in dark robes aboard it. Better still, one of the monks had a white beard.

I swung around toward the stern again, focused on my gondolier, and waited until the second boat moved into position, giving me just the composition I wanted. I had one chance, that's all, but I caught it. If you train yourself to think fast enough you can sometimes *anticipate* a picture, as I was able to do here, and be ready for the critical split second when everything falls into place. (But don't be disappointed if you miss sometimes; that happens, too.)

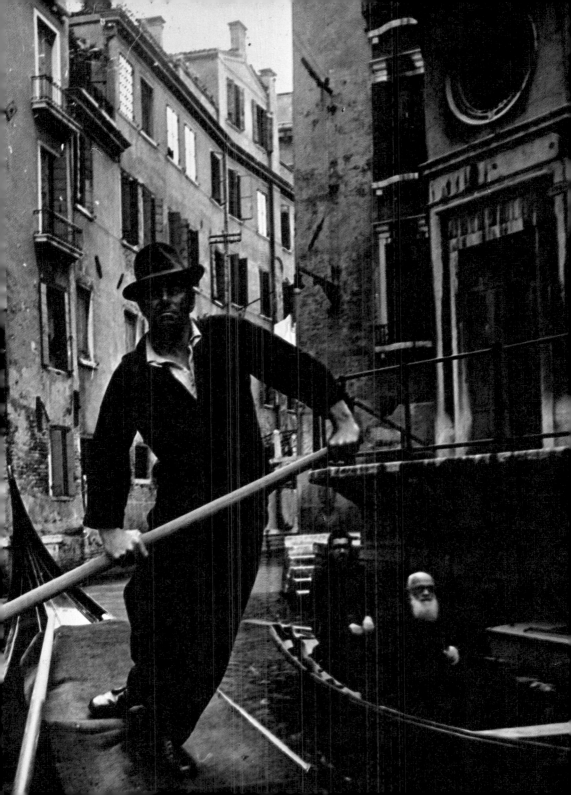

V FOR VICTORY: Another time when I didn't know what was coming occurred in Liverpool, at a Conservative Party rally during the British election campaign of 1951. Churchill was there, with his son Randolph and other notables. I was concentrating on Churchill, of course, because he was the key figure, and standing as close as they would allow me with a 90-mm lens on my camera.

There he was, sitting right in front of me, and beginning to get drowsy, as you can see in frames 21 through 23 on page 67. In frame 24, he's actually dozed off, his head nodding. Then the band started to play "God Save the King." Randolph poked him on the shoulder. Instantly he shot up, wide awake, making his famous V for Victory sign like an automatic reflex action. I tripped the shutter and frame 25 was the telling picture.

The pictures of Clement Atlee in the contact sheet on page 66 were taken about the same time, at a Labour Party gathering just before the defeat of his party in 1951. The whole story of the campaign is summed up in the faces of the two party leaders: weariness and discouragement on one side, and complete confidence on the other.

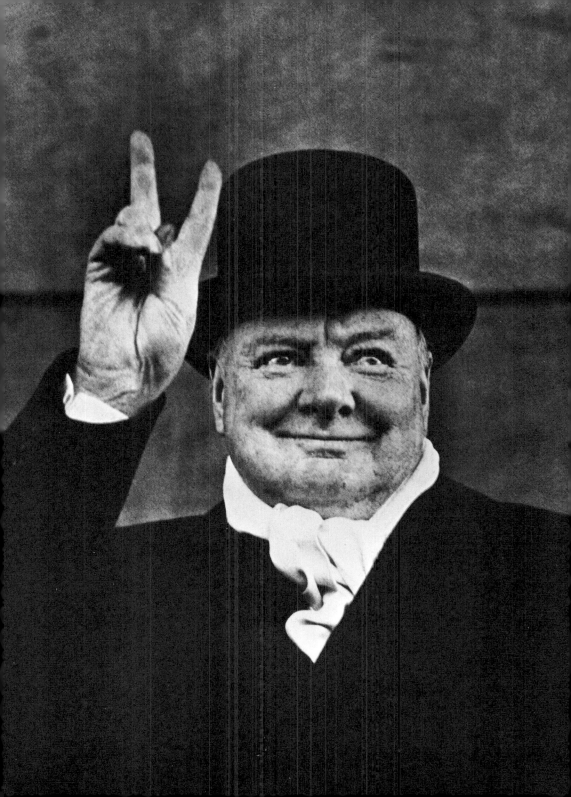

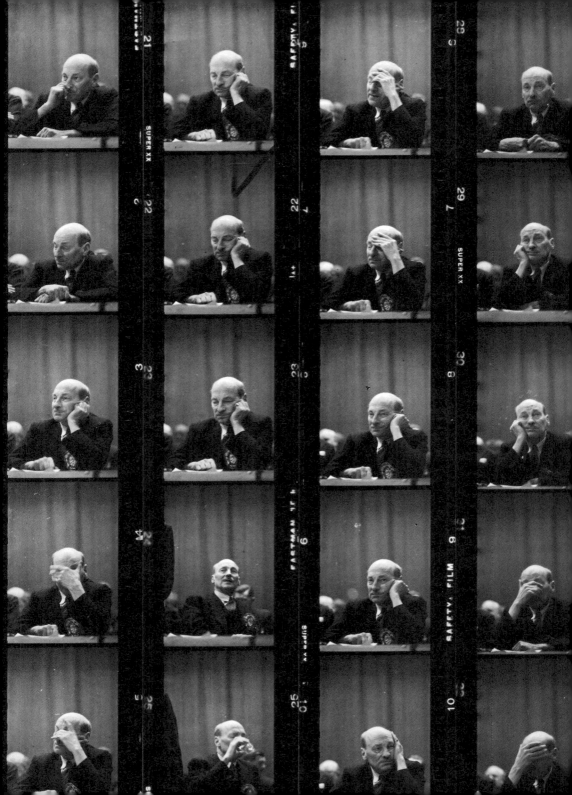

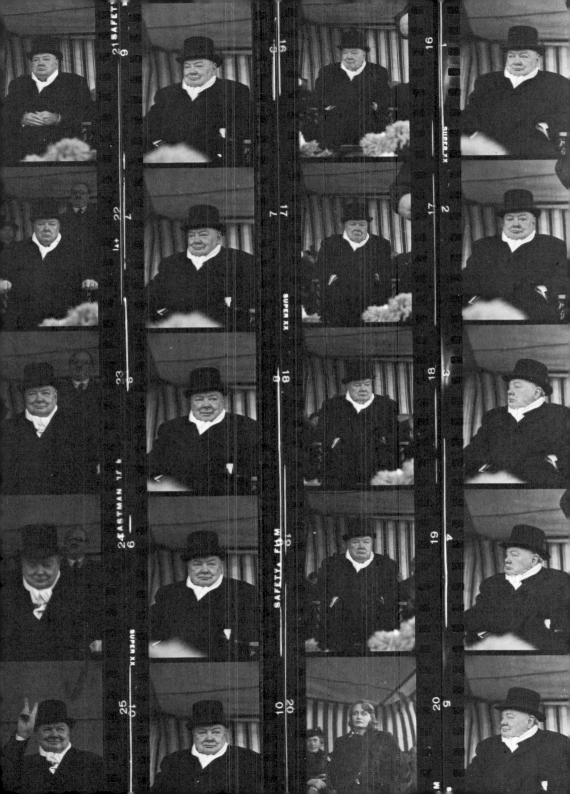

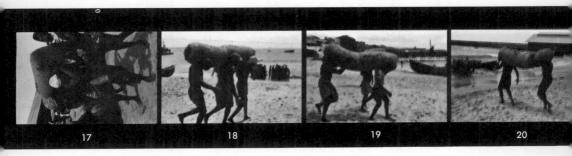

GOLD COAST OARSMEN: As a photographer, you don't always walk into a situation and find your best pictures right away. Often it takes much looking and exploring. These contacts are a good example of what I mean. They were taken in Ghana on Africa's Gold Coast in 1953 just after I'd finished covering the Mau Mau rebellion in Kenya. I came down to the harbor and found it a very busy place: men rushing about loading and unloading their boats, carrying bags of cocoa, oil drums, and sheets of tin. I had my field glasses with me and saw what was happening: the workers were loading their boats, rowing out to a ship anchored farther out, transferring cargo, and returning to the beach.

At first I shot only the activity on land—the men with their heavy burdens and the boats coming ashore through the surf. (Contact strips 17-20 and 40-43.) I came

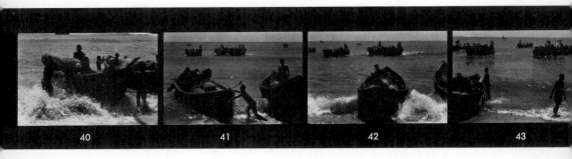

11 12 13 14

back the next day to try again and asked the harbor master for permission to follow the boats out. We got a little motorboat and accompanied the rowers. I made quite a few photographs with my Leica IIIc, but wasn't able to get close enough to the action for a truly powerful storytelling picture. (Contact strip 11-14.)

Then, on the way back, I saw one boat coming close. We maneuvered the motorboat broadside. I shot very fast—four frames—almost like a movie sequence, and caught the rowers quite close as they passed by, straining at their oars, water splashing, sunlight playing on the muscles of their arms and backs. Just one frame— 35—really caught it. The others were too soon or two late. But that one frame was worth all the effort and misses. (Contact strip 34-37. Turn page for enlargement of frame 35.)

34 35 36 37

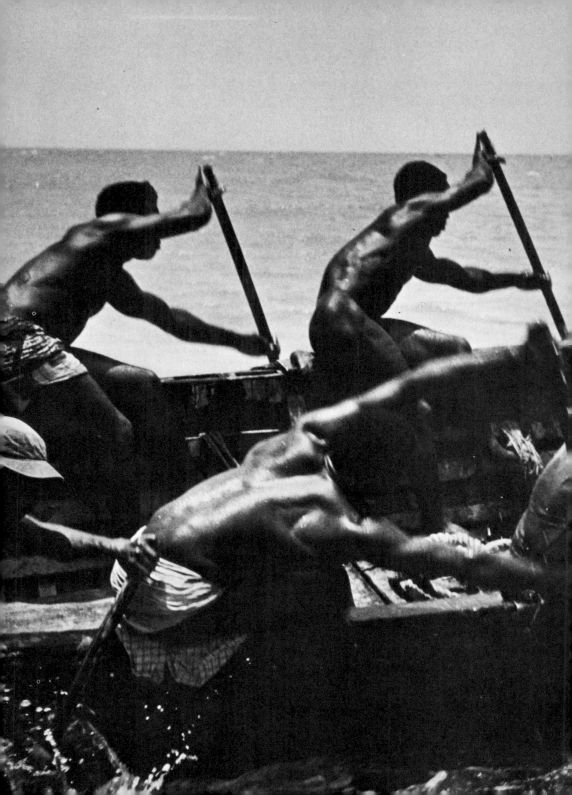

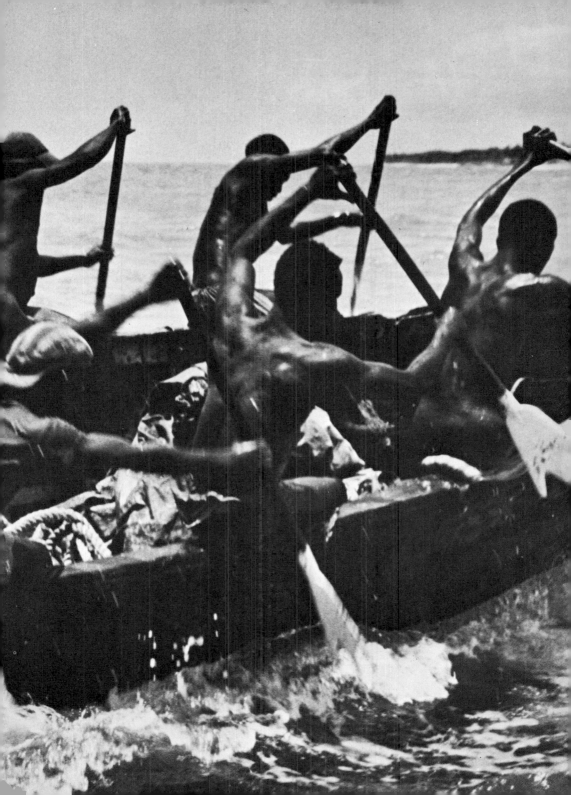

THOMAS SCHIPPERS: Musicians and composers have been among my favorite subjects for many years. In 1967 *Life* assigned me to do a major series on new young conductors, one of whom was the talented Thomas Schippers. I photographed him at the rehearsal of Tchaikovsky's "Queen of Spades" in the rehearsal hall of the new Metropolitan Opera House in New York. Schippers was an ideal subject—a very charming man personally and most animated and dynamic in his conducting. He did wonderful things with his hands, his arms, his expression.

Photographing action like this is unpredictable, of course, but I've found it helps very much if you can sit through one cycle of rehearsal, just looking for the most exciting moments, before you shoot. The next time you often can anticipate the times when something good will happen.

In frames 20 through 23 Schippers was reaching a climactic passage in the piece he was conducting. Suddenly he leaned forward with his arms spread like wings. He reminded me of an eagle (not a bald eagle, of course, but a blond eagle). On frame 24 I caught him just right.

For this shooting I used available light and Tri-X film rated at 400, with a Leica and 35-mm lens. Unlike the early days of my available-light picture-taking, this was hand-held, not on a tripod, because I was able to shoot at 1/30 or 1/60 second and f/5.6 or thereabouts.

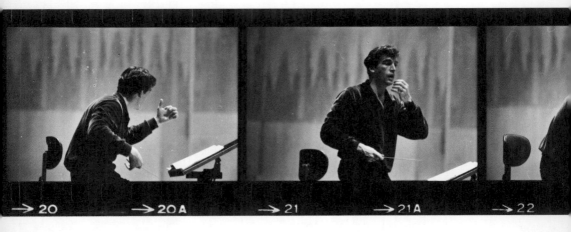

→ 20 → 20A → 21 → 21A → 22

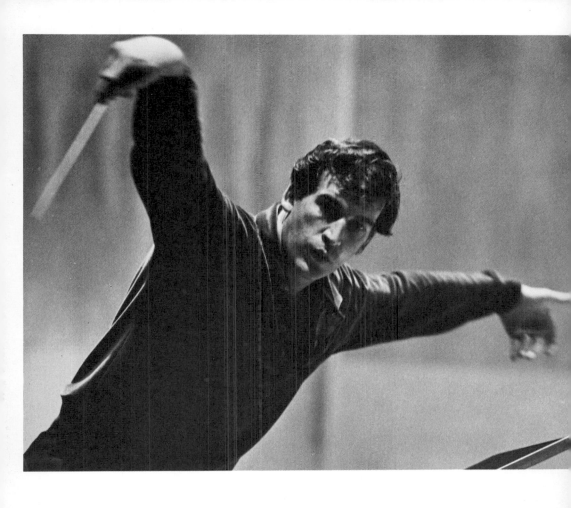

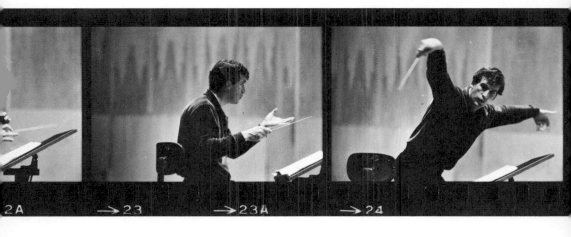

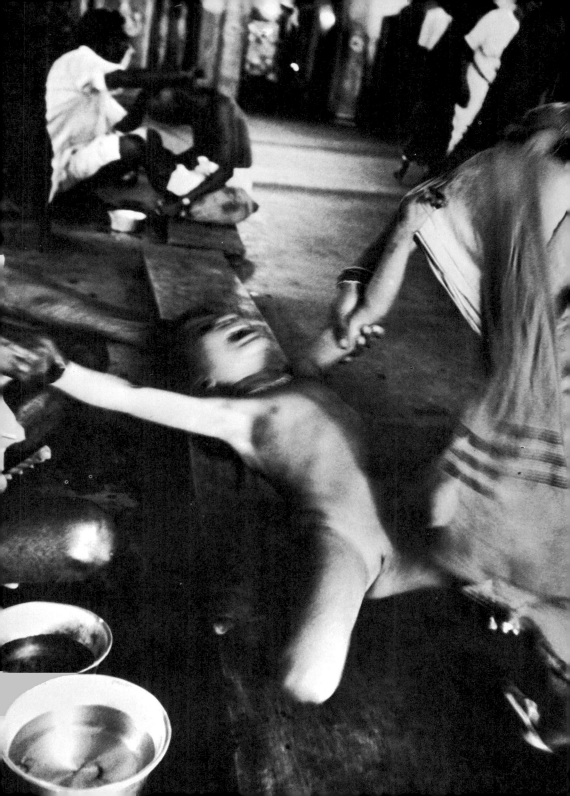

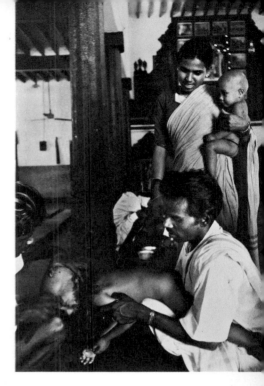

A RITUAL HAIR-CUTTING IN INDIA: Often you must work very fast, even though conditions are far from ideal. These pictures were made at a holy place in Thirupati, India. Members of a special sect of Hindus have their hair shaved there as a gift to Buddha.

I arrived at the temple in the afternoon. Inside, there were more than fifty barbers, all busy. Oh, what a story, if I'd had the time! But I could only make a very few pictures. I concentrated on this one little girl. She was frantic, struggling and screaming with fright. This was very difficult to get: the light was very dim and so none of the photographs is really sharp. I was exposing at about $f/2.8$ and 1/30 second on ASA 400 film. I didn't ask for permission; I just pointed my camera and shot very quickly. If you see something exciting you must act fast. Don't stop to worry about the light or the exposure. If you do, you may lose the picture forever.

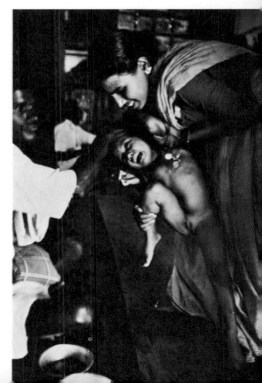

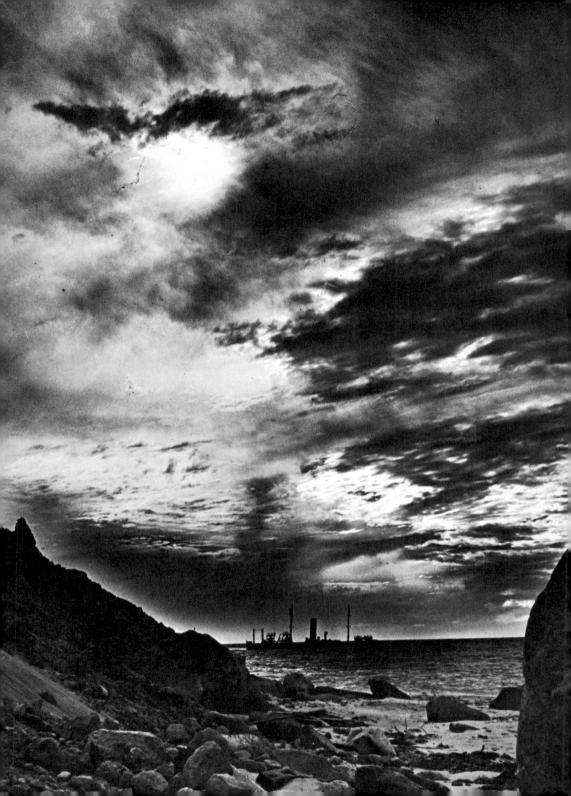

A FEELING FOR LIGHT

The way a photographer sees is different from the ordinary way of seeing. It involves an awareness of things that a nonphotographer isn't sensitive to. Take light. It's the basic energy that produces an image on a piece of film. But it's much more than that. Light, with all its infinite changes in quality, is very often what *makes* the picture, in terms of mood and atmosphere and emotion.

There are photographers who cannot take good pictures because they don't see the light which is there. They see only in terms of electronic flash. They work with at least ten strobes and many assistants. I hate that. I don't like to work with assistants. I'm already one too many; the camera alone would be enough.

In my work I rarely find it necessary to add to the existing light. Sometimes, in making a portrait in a room with poor lighting, I may reflect light from one small photoflood off the wall or ceiling. But that's all, and I'd rather not do it unless I absolutely must. With color, too, sometimes you must supplement the existing light, but with the faster and better color films being made available today, even this isn't necessary so often any more.

Over the years I've trained my eyes to be very, very aware of light. Even when I sit in a room and read, I subconsciously notice how the light changes when a cloud passes across the sun. When I'm on location, I *feel* the light. Very often I'll put my hand out and turn it, testing different positions to see if the light is favorable or not. You must be observant and train yourself until this awareness becomes habitual and automatic. Then you can make decisions, the right decisions, in a jiffy.

Once, during an interview, I said something about this ability to "feel" light. The interviewer looked puzzled. "You mean you feel light with your fingers?" he asked. No, of course not. You sense the light with your eyes and respond with your emotions. But this kind of visual-emotional response is very real, nevertheless, and I don't know any better way to describe the process than to call it "feeling."

In my early days as a photographer I spent much of my free time visiting art museums and looking at paintings in terms of lighting and composition. I was impressed with the way the old masters handled lighting, especially Rembrandt and Rubens. I'm sure this has had an effect, conscious and unconscious, on the way I've seen light and used it in my photographs.

The fascinating thing to me about nature's light is its endless variety. Ocean waves have been breaking against the shore for billions of years and yet no two waves ever are exactly the same. No two sunsets ever are identical, either. The light of nature constantly shifts and changes, and you must be alert to take advantage of the best moments. It is always astonishing to me how much the light will alter the appearance of a scene. One instant an expanse of water is dull, flat, and lifeless—no picture. The next instant the sun comes out and the water bursts into fire, sparkling like diamonds.

Bad weather often is good news for a photographer. I love fog, clouds, and overcast skies. Think in terms of silhouetted shapes, as the ship and rocks in the photograph on page 76, made at Gay Head, Martha's Vineyard, in 1948. Expose for the bright areas of the sky and let the foreground go dark.

For a dramatic touch, direct sunlight can do the trick. I made this back-lighted portrait (opposite) of the artist, Thomas Hart Benton, in his studio. I exposed for his shadowed face, but a beam of sunlight from a skylight strikingly illuminated his silvery hair.

On the following pages are several of my pictures, some quite old, others more recent, that show more vividly than I can express in words what I mean by a feeling for light and what it can do for a photograph.

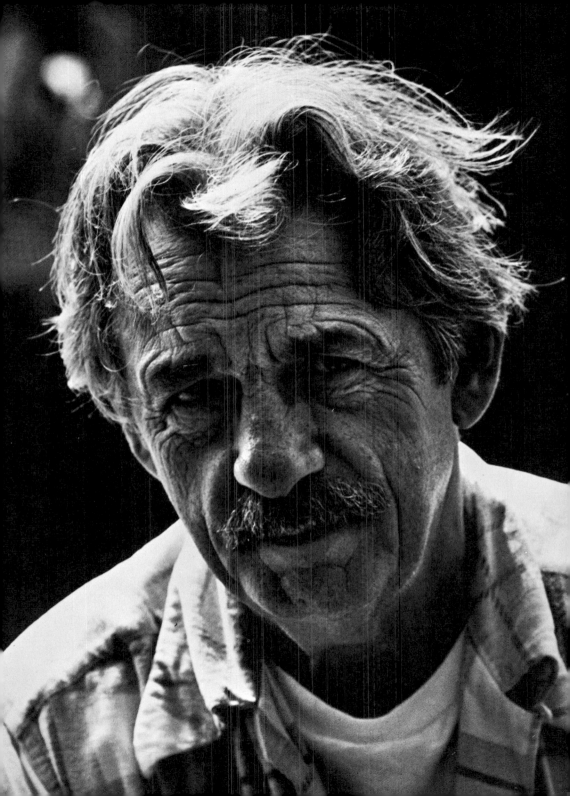

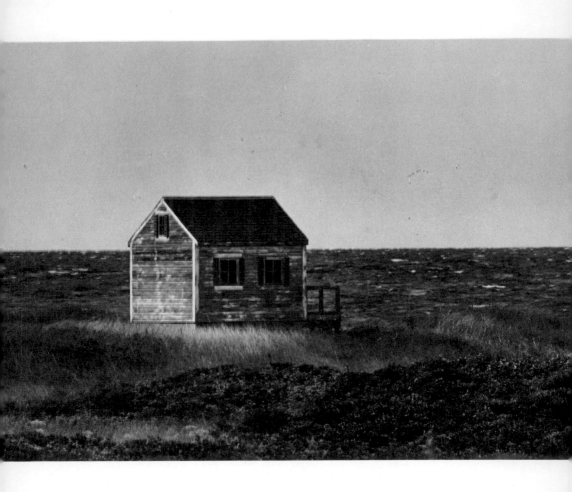

The magic of light is typified for me in these two photographs of a lonely shack on the beach at Martha's Vineyard. In flat, front lighting, the scene is nothing.

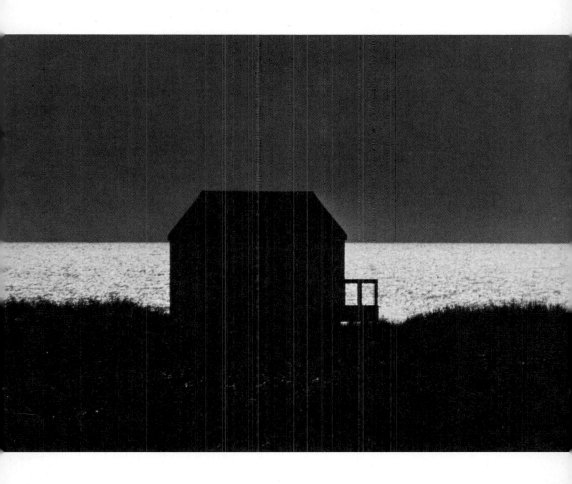

But see how interesting it becomes when the afternoon light makes the sea sparkle and the shack is recorded as a silhouette.

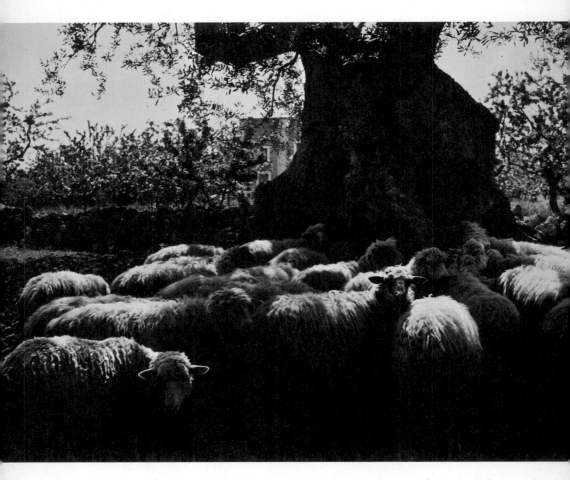

I often take pictures straight into the light. Here's one of sheep under an olive tree in southern Italy. You must use good judgment in exposure; you can't generalize. I wanted some detail in the shadow areas—not just silhouetted shapes—and so exposed accordingly.

This is an early photograph on very slow film. The beautiful Rembrandtesque illumination from the skylight was captured with about a one-half-second exposure, using a tripod.

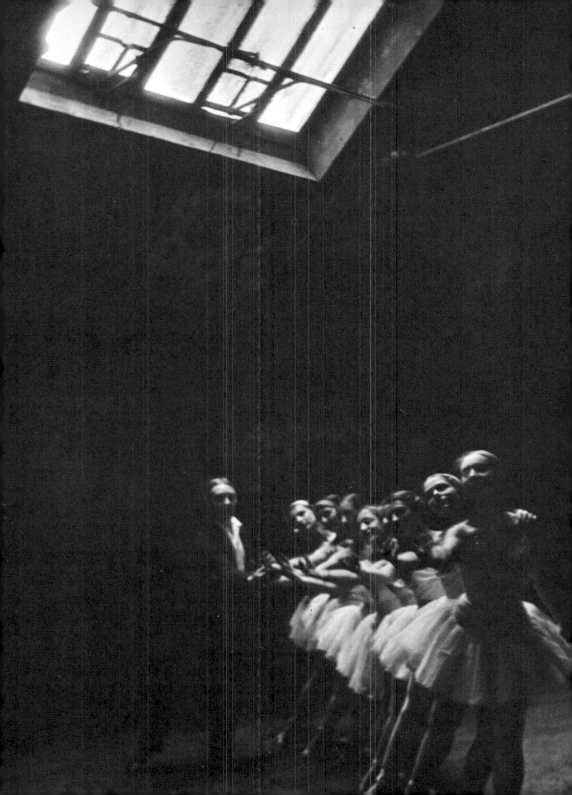

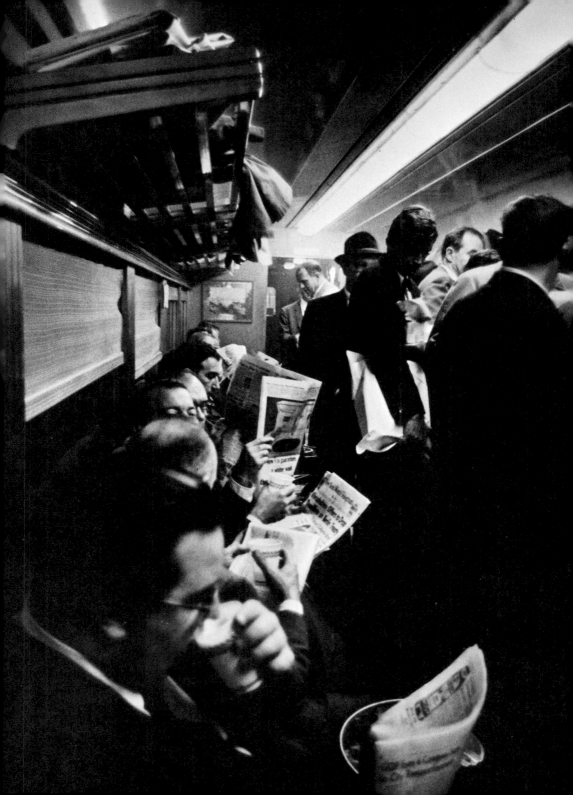

From my very early days as a photojournalist I've been fascinated by the beauty and authenticity of existing light indoors—untouched by flash or flood. The commuter's-eye view of a New Haven railroad train in 1961 is an example. It was made with a wide-angle lens wide open at $f/2$ (I focused on the man with a white package near the center of the picture). It's inconceivable to me that this picture would have retained its mood if I had used anything but the illumination in the scene.

The picture on page 86, of children preparing for a ballet, tells its story in a vital, pictorial way. The sunlight silhouetting the skating figure at Davos (page 87) gives dramatic intensity to the scene and heightens the point of the picture.

It's sometimes exciting to include the sun itself, as in the photograph on page 88 of a lovely winter morning in St. Moritz, in 1947. In the color photograph (page 89) the sun *is* the picture, in a sense. I took it with a 400-mm telephoto lens from the bedroom of my apartment. A degree of underexposure is often needed to strengthen the intensity of the colors in a sunset sky.

Some photographers put their cameras away as soon as the sun goes down, but this is a mistake—light at sunset, dusk, and after dark creates some of its most beautiful effects. Look at the three telephoto photographs of the New York skyline in color on page 90. All were made within a very short space of time—but what a change in mood and quality as the sky deepens in color and the lights of the buildings are turned on! On page 91, St. Peter's in Rome is illuminated with strings of light. The fountain adds interest to the foreground.

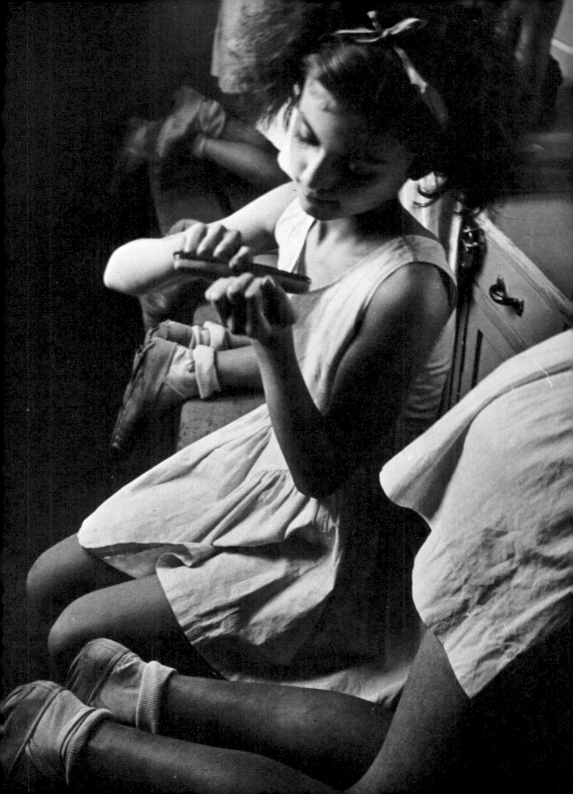

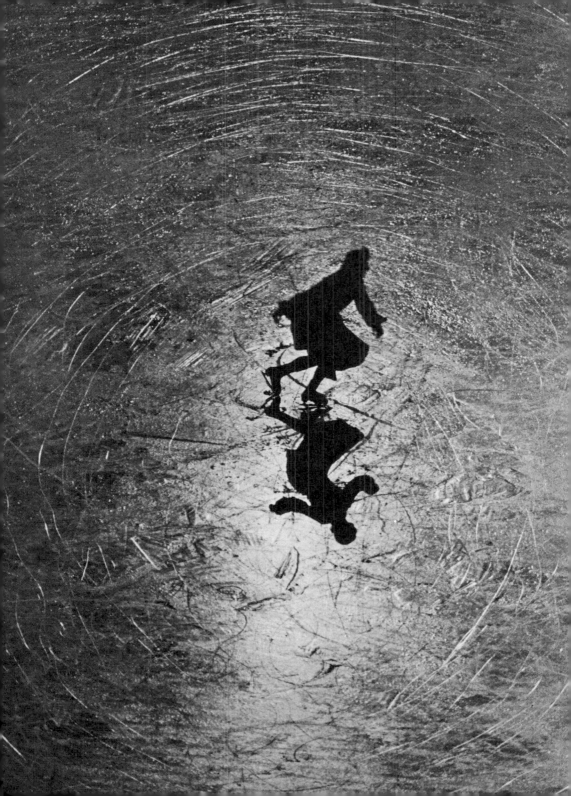

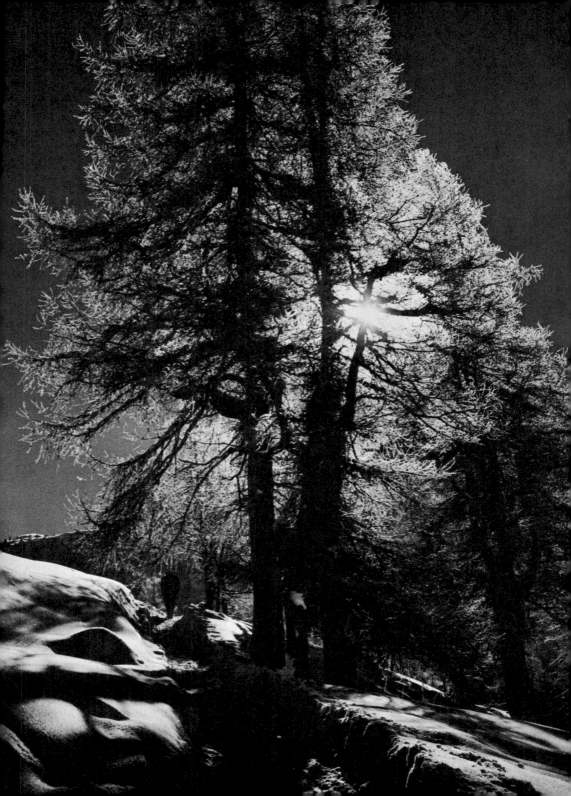

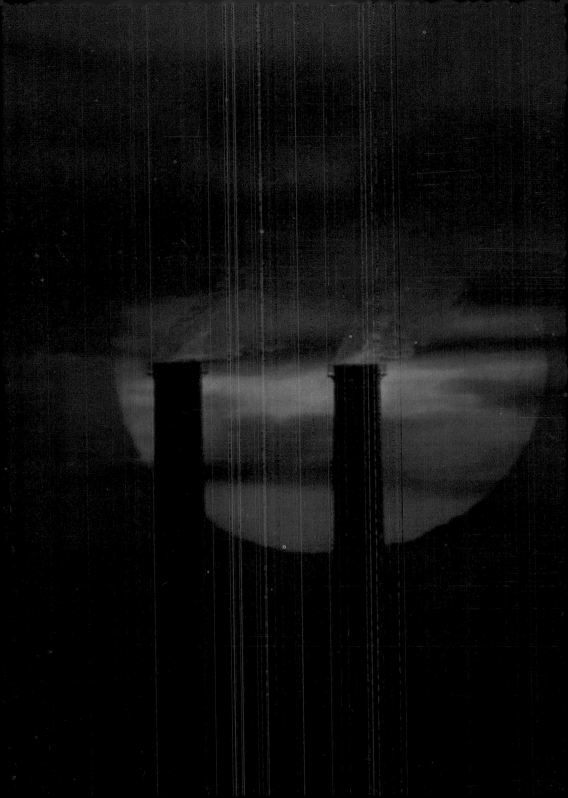

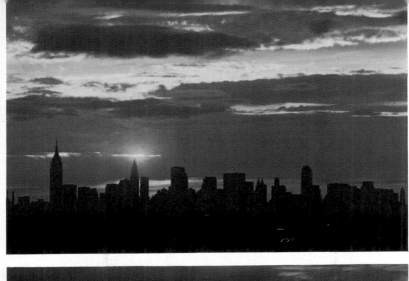

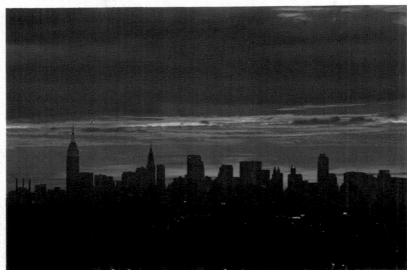

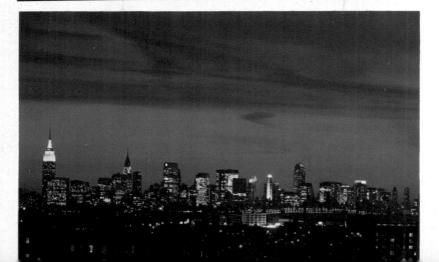

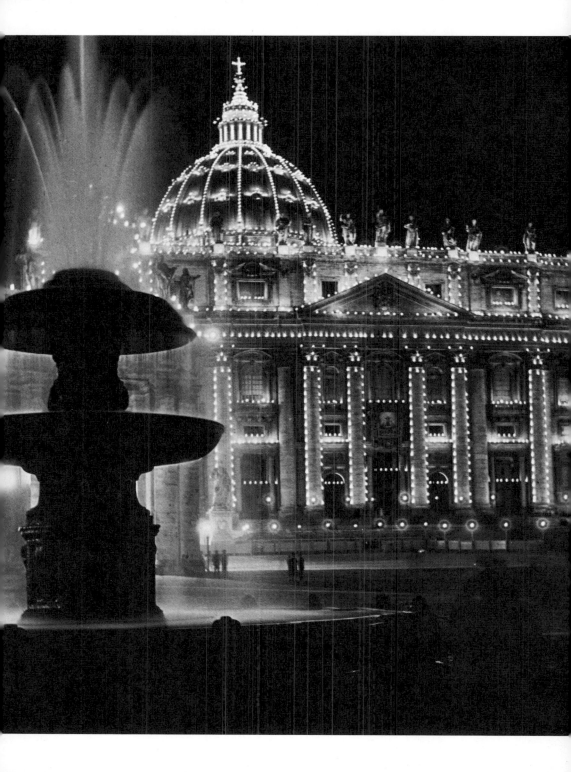

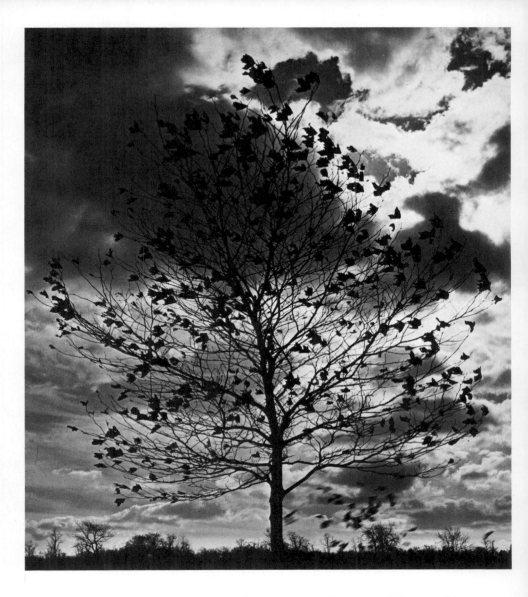

Silhouettes are useful—but the shapes must tell a story. The windblown tree above provided the lead illustration for a story on approaching winter in *Life*. A meeting at the United Nations also provided a strong picture, especially since the profile of Khrushchev (at right) was instantly recognizable. I wanted to step forward a little, but a U.N. guard held out his hand, so I photographed from where I stood, and included the hand in my picture.

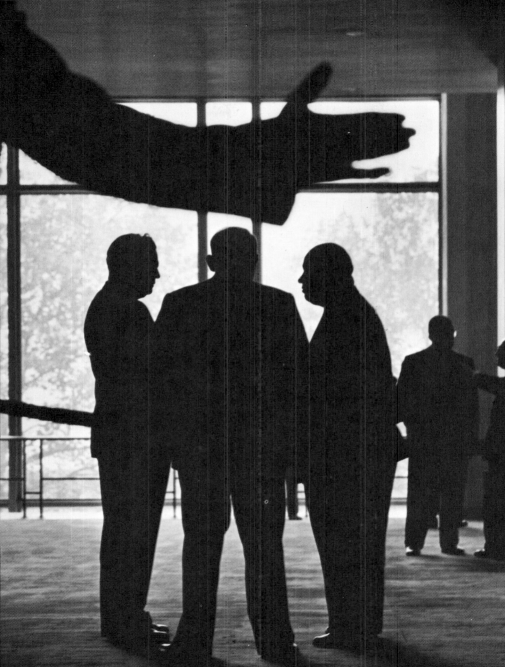

PEOPLE

All my professional life I've been photographing people—kings and dictators, musicians and movie stars, farmers and workers, men and women, the young and the old. My assignments have brought me in contact with an incredible number and range of human beings. When I look back through my files I feel amazed: did I really meet all those people and take all those pictures?

I've never tired of taking "people pictures" for my own pleasure, as well as on assignment. It's one of the most exciting, interesting things you can do with a camera.

To succeed you must like people and have them like and trust you in return. If you're impatient, think only of getting things right for yourself, and push your subject around, you'll have trouble. Instead, you must be a psychologist. You have to be able to sense very quickly when you meet someone whether you can backslap him right away and call him by his first name or whether to be reserved and formal.

For instance, when I first photographed Sophia Loren, we clicked right away, and she has been one of my favorite subjects ever since. Churchill, on the other hand, was a very difficult subject. I once had an appointment to photograph him at home, at Chequers. The appointment was for two o'clock and he didn't appear until four, because of a long lunch with a friend. Churchill said, "Young man, you can't take me from that position; you have to go over there. I'm a photographer, too. I know my best angles, and I know where you should take my picture from."

I was a bit hesitant but the friend came over and said in my ear, "Look, Winston always has the last word, so do just what he says. Then you can try it your way." Which is exactly what I did, and it worked.

Diplomacy and psychology are valuable for photographers as well as politicians. If I visit a family to photograph them and somebody says, "Here's a wonderful picture for you—look at our dog, here," I may think, "Gee, horrible dog." But I'll

take that picture. It disarms people and helps establish the right atmosphere for getting the pictures *I* want. What does a wasted shot or two matter? Film is the least expensive thing in photography.

Many photographers are shy about photographing other people, especially strangers or important personages. I used to be that way myself. You just have to be bold and plunge in. Self-confidence comes with experience. I never have forgotten something that Wilson Hicks once told me when he was *Life's* picture editor. "Never be in awe of a king, a movie star, or anybody. You are a king in your own profession. A king is a servant of his people just as you are employed by a magazine." I've found this idea most comforting.

You must talk to people, put them at their ease, and help them forget, at least momentarily, that you are a photographer. This is why I often prefer to use a tripod for my portrait work. If I keep putting my camera up and down to my eye, this is distracting. If I put my camera on a tripod, and focus, then I'm free to talk directly to my subject, using a cable release to take the picture. For me, this method often gives the most natural, relaxed pictures.

Of course, you must know *what* to talk about. You don't want to seem uninformed. So I read a lot, and try to keep abreast of what's going on.

In this section are some of my pictures of famous people, and again, perhaps they will show you more clearly than words the kind of seeing that a photographer needs in his work.

I photographed Robert Frost (overleaf) at his little house in Ripton, Vermont, in 1958. We got along very well. He had a voice like that of a raspy, good-natured old buffalo, and he wrote a complete poem for me in my autograph book. We began with inside photographs at his desk, then I asked him to go outdoors. We walked through the surrounding fields and woods. I noticed a rugged boulder in a pasture and asked Frost if he would sit on it. I made a number of photographs with a 35-mm lens, and this is my favorite.

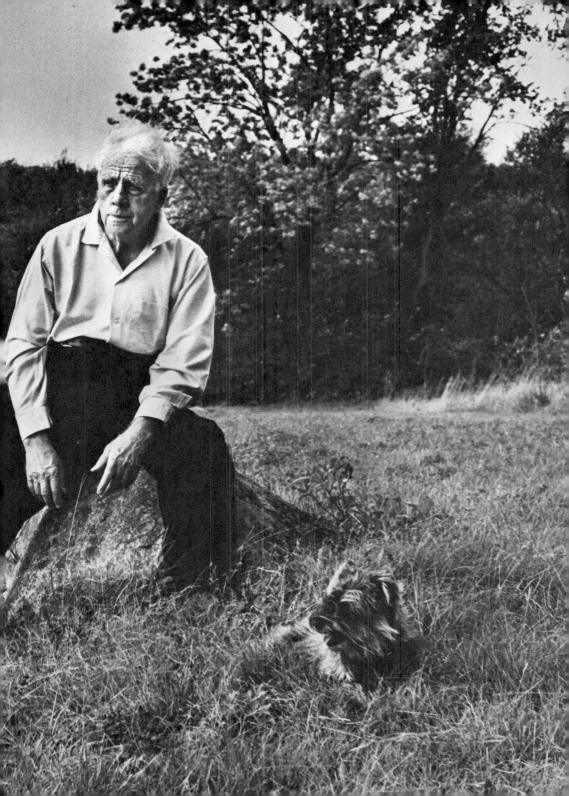

These photographs of journalist Ernie Pyle were taken a few months before he was killed in the Pacific, during World War II. The light in the studio of sculptor Jo Davidson was beautiful and I took a number of pictures, using a Rolleiflex. Helen Keller visited Pyle there, touching his face with her fingers, "seeing" him through their tips. "You have a wonderful face," she told him. And indeed he did.

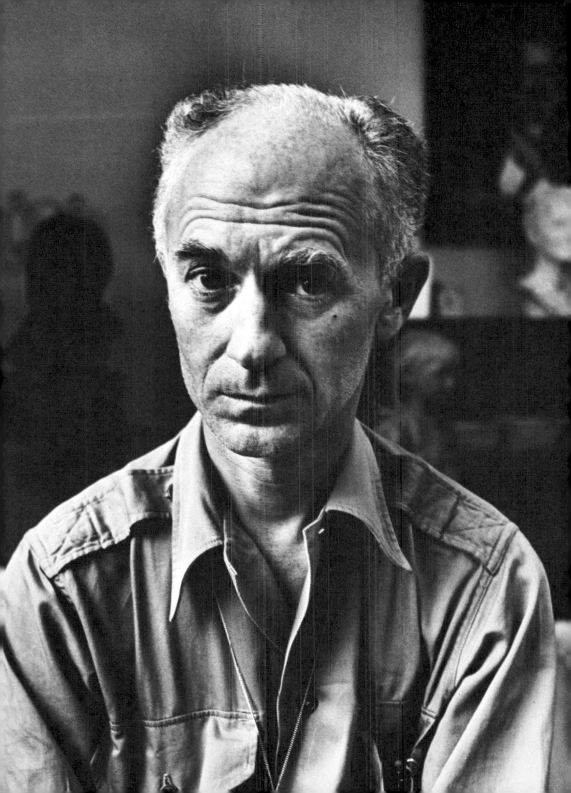

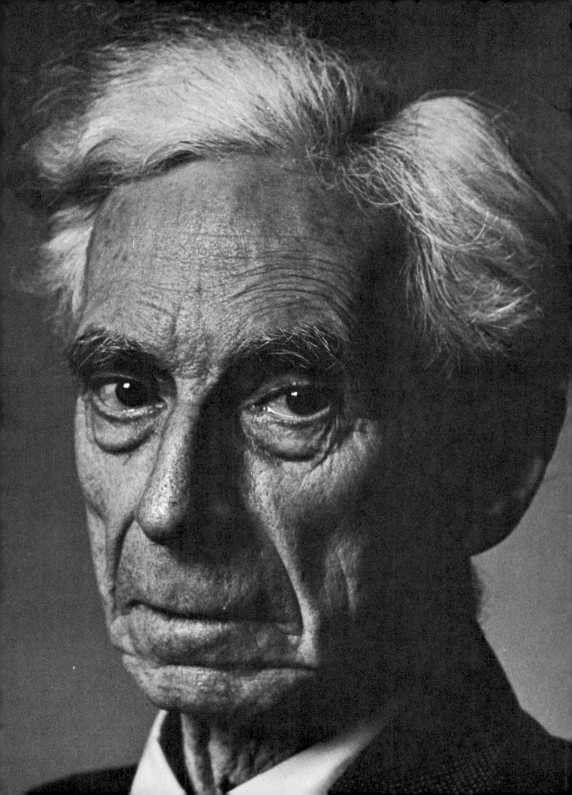

One of the most strenuous assignments I ever had was a series of portraits of distinguished Englishmen in 1951. Because of timing and other complications I had to photograph twenty-seven people in about eleven days. Three reporters helped me set the schedules and I traveled day and night in cars, trains, and planes.

In order to arrange sittings for all these people I told each one: "It will take only ten minutes." Once you're there and the ice is broken, and you say, "Well, it's time to go," the subject usually will say, "Oh, no—stay a little longer."

This portrait of Lord Russell, one of my favorites from the series, was taken in his home with a 135-mm lens, and my camera on a tripod while we talked. I'd brought along a photoflood but didn't use it because there was enough daylight. Russell was a most interesting subject, but quiet that day. I told him I never saw a man so quiet. "You are like a figure of stone," I said. He looked at me and said, "A crocodile doesn't move much," and that's when I took this picture.

Is there a difference between men and women as photographic subjects? Every individual is different, but at least one generality holds true. When you tell a man you're going to take his picture the first thing he does is straighten his tie; a woman freshens her make-up.

The Sophia Loren picture (page 102) was taken in Italy in 1961. We were having lunch together at a little table in a cafeteria. As we talked, I took pictures with a 90-mm lens. It was all very relaxed and natural, the best kind of atmosphere for a photographer.

The photograph of Marlene Dietrich (page 103) goes back to 1928. I took it with my Ermanox at a party for the foreign press in Berlin. She was working on *The Blue Angel* and came to the party wearing men's attire. It was a very exciting moment for me, as I was still mostly an amateur photographer.

The photograph of Marilyn Monroe on page 104 was taken in 1954 on the patio of her home in Hollywood. She was a bit flustered, and perhaps I was too. Somehow, I mixed up the markings on my two cameras. (One was loaded with color and the other with black-and-white film.) As a result, many of my exposures were off. This is one of the good pictures from that enjoyable visit.

The picture on page 105, of Leonard Bernstein, was made at a rehearsal of Gustav Mahler's Second Symphony in 1960.

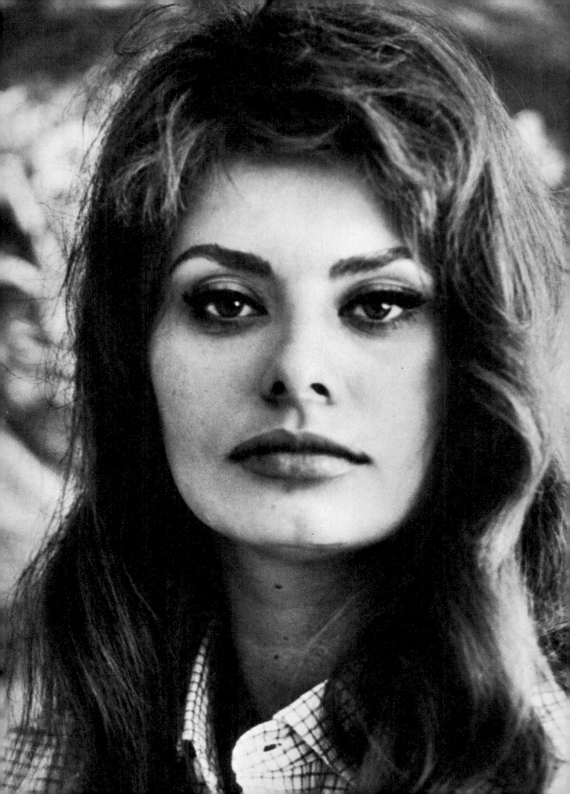

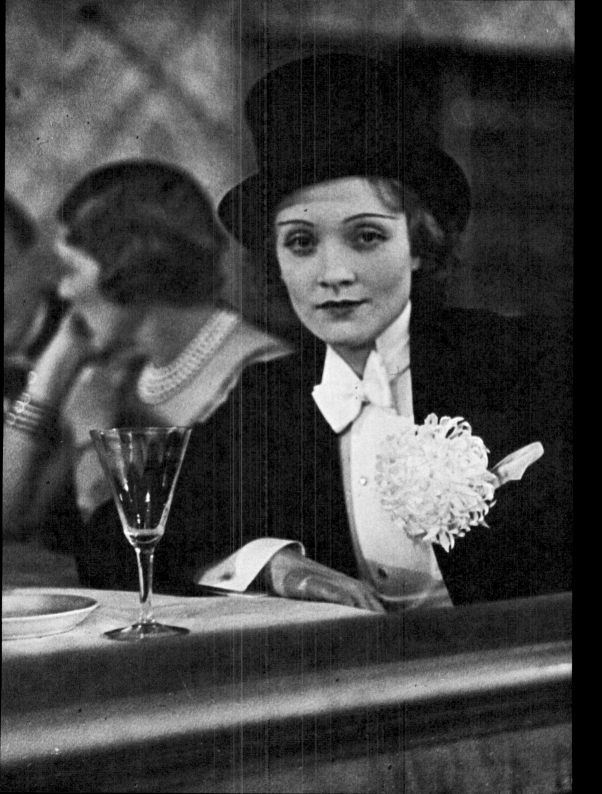

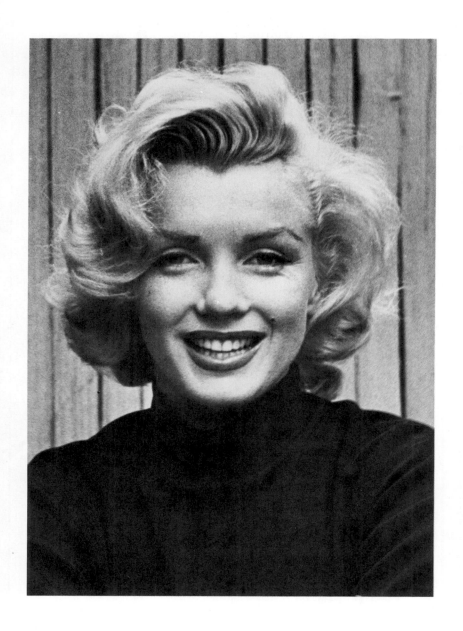

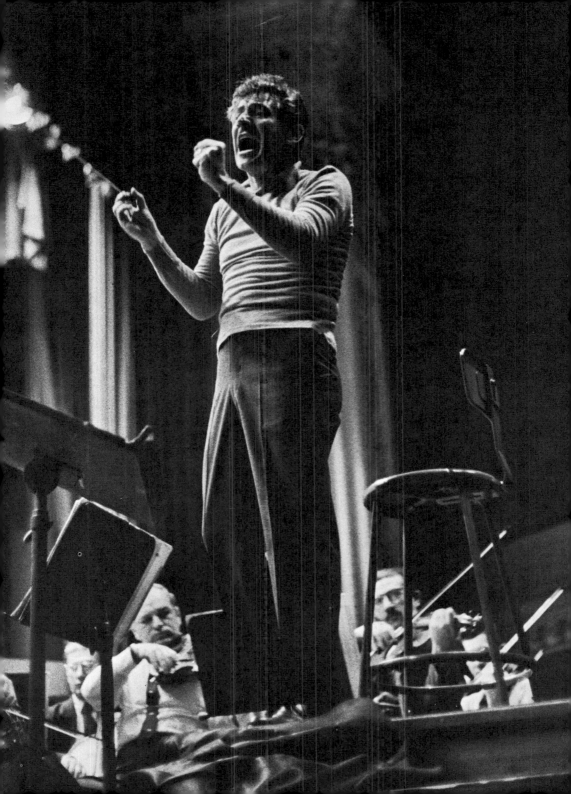

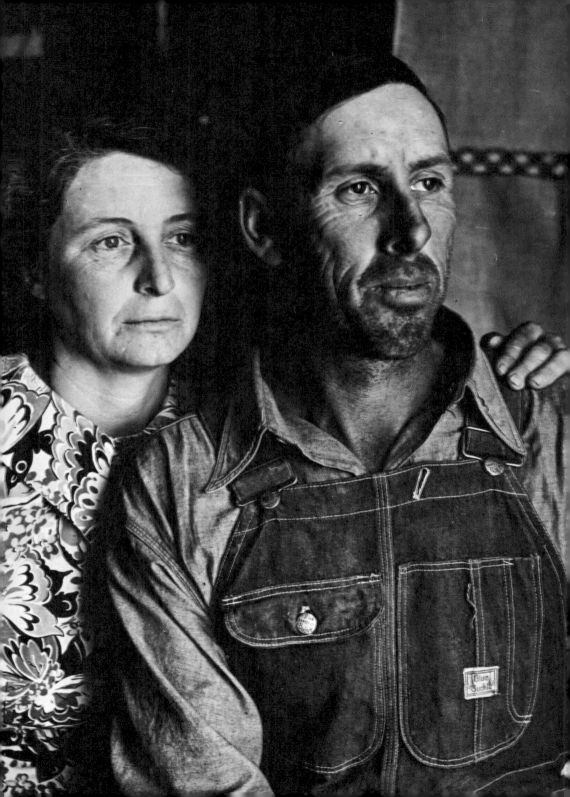

Most of the pictures of people I take are in their own environments. That was the case here, with this Oklahoma husband and wife. It was made in the early forties, and they were a sharecropper family on a small, rundown farm—a family who decided to stick out the dust bowl, despite the drought and soil erosion.

They were fine people and very cooperative. I asked them to step out onto the porch, and there I took this double portrait. It's a "posed" picture rather than a candid one. I directed them to stand together and asked the wife to put her arm around her husband. As a photographer you sometimes must direct your subjects because they are otherwise at a loss as to what to do. The important thing is to understand what they would do naturally and get them to do that. You don't force them into any unnatural situation or activity. Here they fell together quite naturally into a tightly knit composition as they looked out over the parched fields of their farm.

If I did it again, I'd change my angle, though. I don't like the way the man's dark hair merges with the shadow behind him. This could easily have been corrected if I'd moved my camera just a bit more to the left.

By now I've learned that the most important thing to do when you photograph somebody—in a room or outside—is not to look at the subject but at the background. You want to be sure it's quiet and undisturbing. First figure out the background, then you're free to work with your subject.

I'm not famous as a photographer of nudes, but I think this is a rather good exception to prove the rule. The picture was made during my first Ethiopian trip and the subject was a beautiful girl: a model and a friend of a painter. At first she refused to be photographed in the nude. I put my Leica, with a 90-mm lens, on a tripod. I said, "I won't look when I take the picture." First I focused carefully, then I turned my head away and made the exposure with a cable release. This made everything okay with her.

The photographer sometimes is like a lion caught in a trap. You have to think of *something* in order to escape—and do it quickly. Perhaps what photographers need is not so much a high IQ as a *fast* IQ. You need an ability to be quickly inventive, especially when your subject is a person.

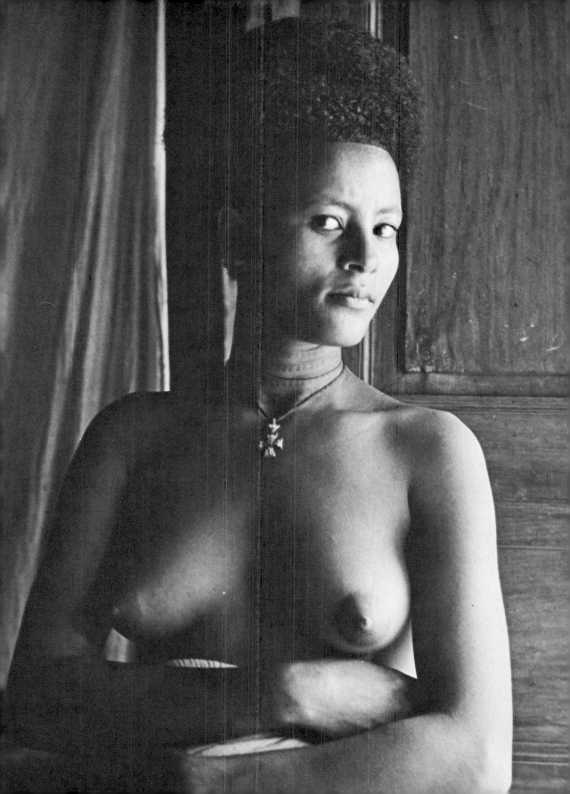

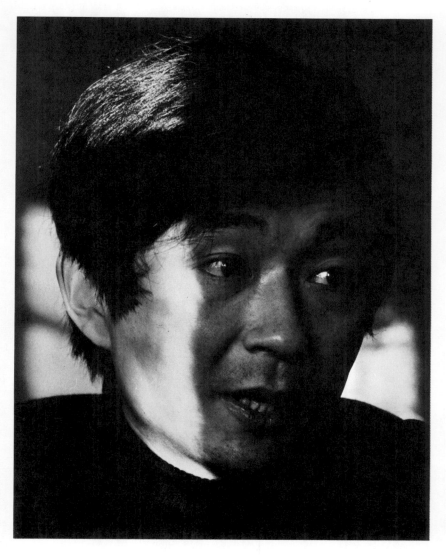

Here are two shots I especially like. The first is the young conductor Seiji Ozawa, taken in 1967 with a hand-held Leica, by available light. As he stepped forward, a shaft of sunlight fell across his face. I exposed for the light area so it wouldn't block up, not worrying about the shadows.

The railroad switchman also is a 35-mm picture, made during World War II at a steel plant in Wheeling, West Virginia. A low angle shows him spread-eagled against the sky, with just enough background details to identify the location.

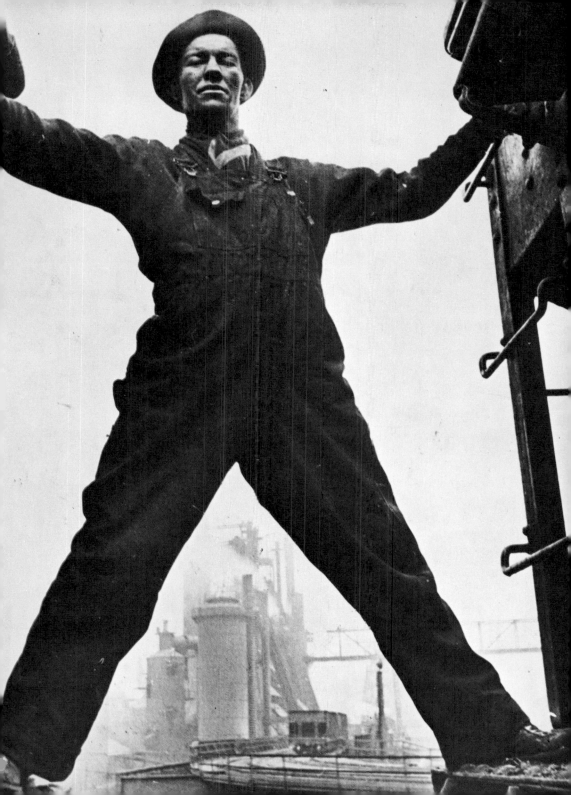

The following three portraits have two things in common: the subjects were all men of extremely high intelligence, and each has a blackboard for a background.

Robert J. Oppenheimer I photographed in his office at Princeton's Institute for Advanced Studies in 1947. The blackboard, on which he often scribbled mathematical figures, made a good background and also was representative of the man. At that time, Oppenheimer was what I would call super-nervous, wound up tight, moving quickly, chain-smoking cigarettes. I caught what I felt was a characteristic gesture.

You must observe the patterns of movement and expression of your subject. Then you often can anticipate a revealing, meaningful moment and be ready for it when it comes. To be the great anticipator: that's a qualification for success in this kind of photography.

Oswald Veblen, photographed at the Institute (page 114) also was a brilliant man but quite different in quality. I was looking for photographs that expressed the idea, "people thinking." I went into his office and there he was, sitting in front of a blank blackboard, wrapped in thought. He looked up when I came in and I said, "Oh, no, Professor Veblen, just forget I'm here." He did. He really was thinking when I took this picture, a mind far away in thought. I used a Rolleiflex here, which is almost noiseless, and he wasn't disturbed by it.

I photographed Norbert Wiener at the Massachusetts Institute of Technology, in Cambridge. He loved music and singing: a very gay, very nice man. He liked cigars and I bought him a box, which helped things along. After taking many shots of him teaching, I wanted one of him alone in the classroom, and saw the possibilities of the light, the chairs, and the blackboard. In a sense I staged this one because I asked him to sit down and write something in my autograph book. That's what he was doing when I moved off and took the picture reproduced on page 115.

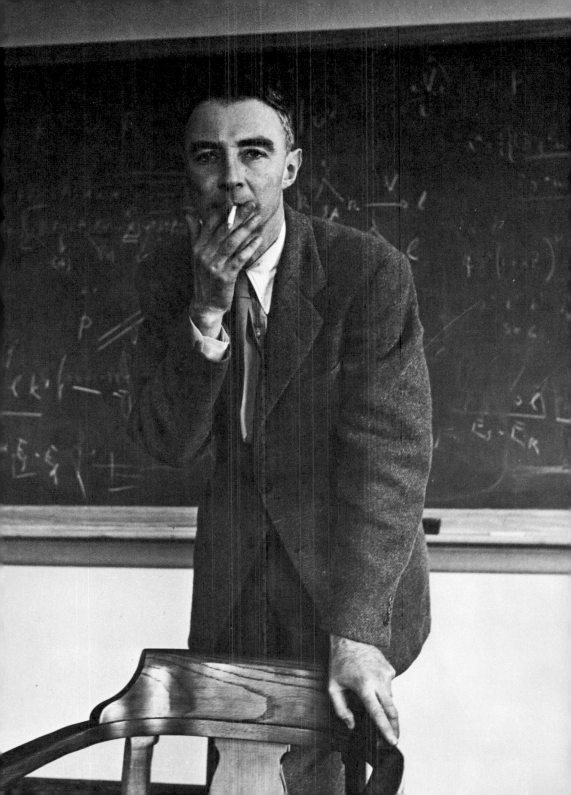

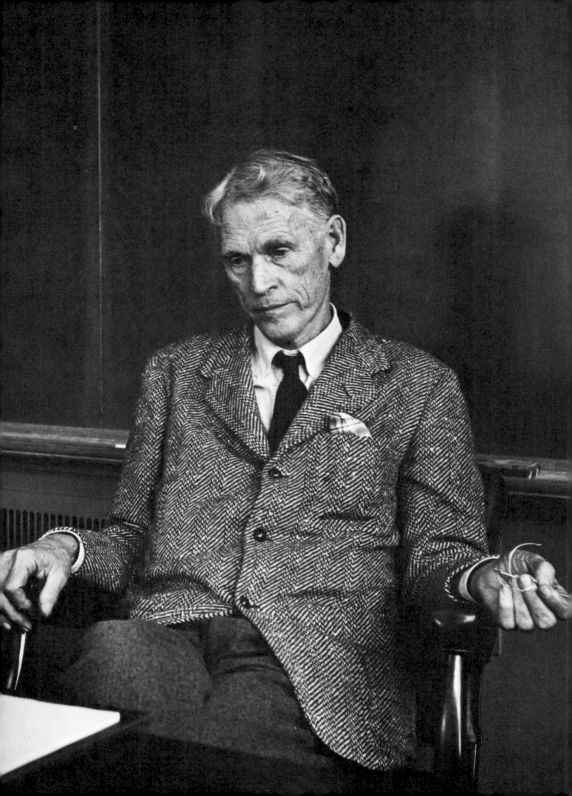

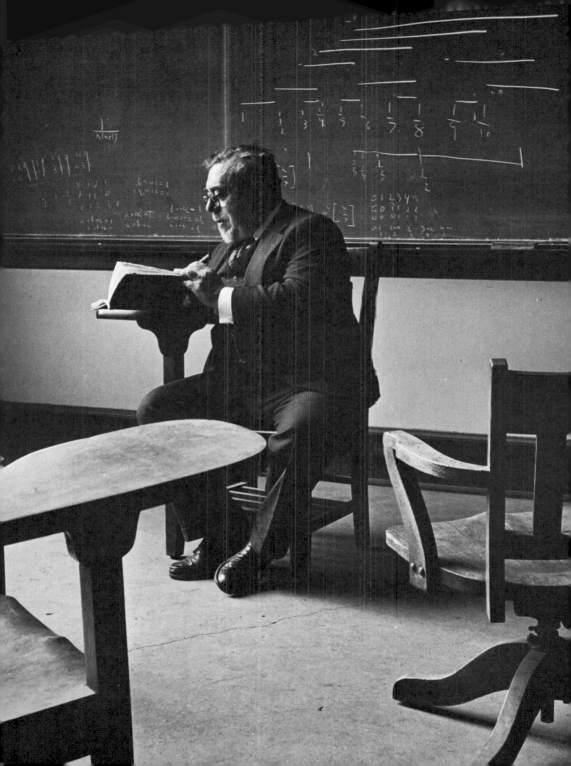

These pictures of Andrew Wyeth's son, Jamie, were taken in Maine. Both were made within moments, from almost the same spot. The first, with its flat lighting, is a satisfactory portrait but I liked the dramatic sky and sunlit water, so I also photographed him from behind. Printed dark, this makes a much more dramatic picture. Of course, this wouldn't stand alone as a portrait, but it is a good example of the amazing difference a simple change of camera angle can accomplish.

This pair of photographs of my friend and former co-worker, Gordon Parks, was made in 1968 to illustrate the jacket of his book, *A Poet and His Camera*. We finally selected the one on the opposite page. Both were made within a fairly short space of time in his apartment.

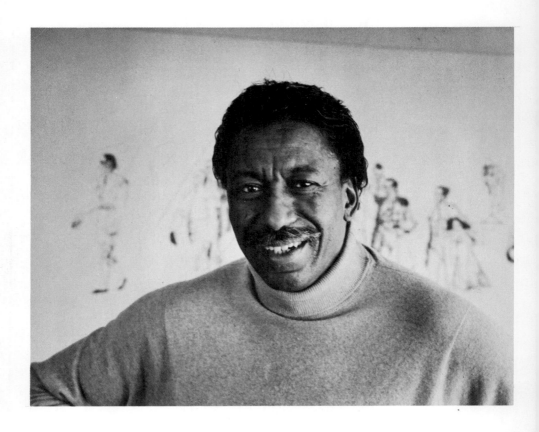

Gordon has a gentle but rugged face. I said, "Smile," and he said, "Eisie, I am a serious man." Rather than force your subject into doing something that isn't natural or easy, it's much better to achieve variety in other ways. We changed the background. We changed Gordon's clothing. I also tried a number of camera angles and lenses, using a 90-mm, 135-mm, and 180-mm (for extreme close-ups). Everything was done with available light and a Leica on a tripod. A wide variety can be achieved even within narrow restrictions.

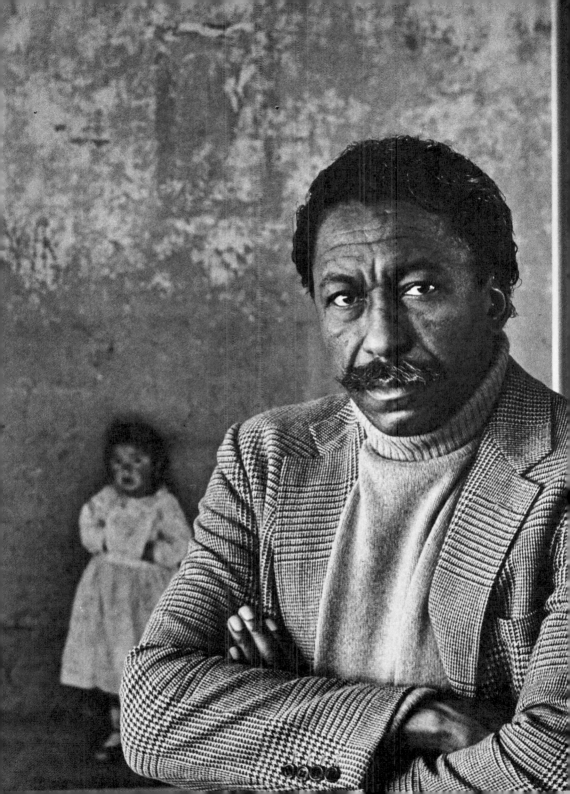

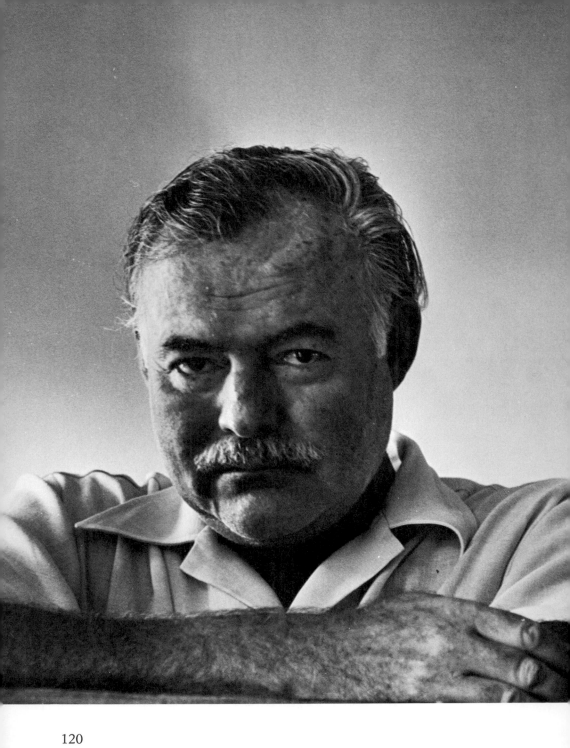

120

People sometimes ask me, "Who was the most difficult subject you ever photographed?" I suppose it was Ernest Hemingway. I visited him in Cuba in 1952 to shoot a *Life* cover and other photographs in connection with *The Old Man and the Sea*. This was a harrowing assignment: Hemingway was highly unpredictable. Often he was really very nice to me, calling me Alfred, but at other times he would fly into a rage and call me all kinds of names.

Getting his cooperation was a challenge to my ingenuity. When I shot the cover picture of him, for instance, he was wearing battered, frayed red shorts and no shirt. I tried to get him to put on a shirt but he refused. "Women like me like this," he said. I knew arguing would be useless, so I had to find a reason to convince him— fast. I said, "The reason I can't photograph you in this outfit is that it's too red. You see, this is a color shot and I need some yellow in it, a yellow shirt." "Oh, I see," he said. We found a yellow shirt and he put it on.

I took other pictures of him in his garden, surrounded by two dogs, his wife, and thirty-one cats. He loved stray cats, and some of these were poor, sick, hairless animals covered with sores and pus. They rubbed their bodies against my legs and my tripod. Now, I like cats, too, but this was very unpleasant and I must have showed it. Hemingway noticed. He got redder and redder and finally came very close to me, eye-to-eye, and said in a threatening voice, "What's the matter— don't you like cats?" "I love cats," I said quickly, "but here I am trying to photograph you and they keep rubbing against the tripod and making it vibrate." "Oh, I see," he said, and that seemed to satisfy him.

You had to be very careful with the man; you could never tell how he would react. In his library, I asked him to climb a ladder so I could make a low-angle shot. I had a feeling the light up there was going to be good for a portrait. However, he thought I was trying to ridicule him. "Look, I'll show you," I said and climbed up the ladder (my camera was already set and focused, on a tripod). He took a look and approved. Only then would he climb the ladder. One of the pictures I got is reproduced on the facing page.

Usually, the more important the man, the easier he is to work with. But there are exceptions. It was a great relief to be finished with this assignment.

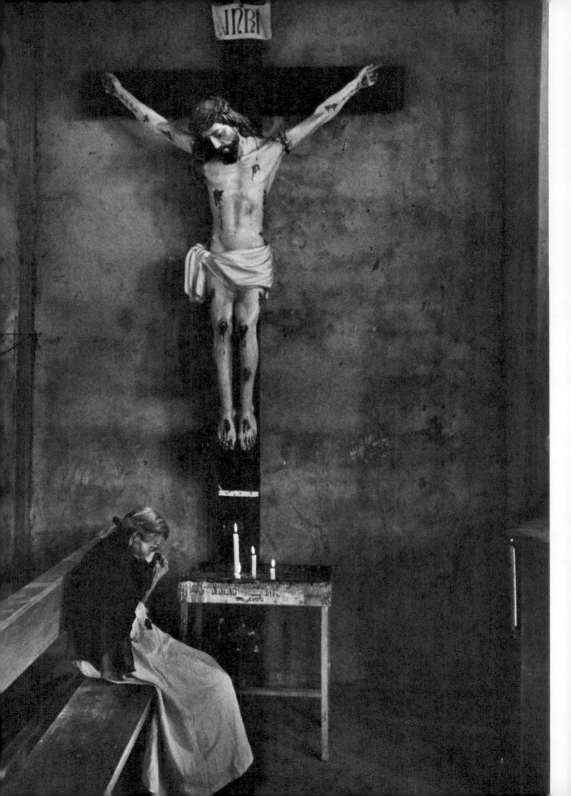

THE DISCOVERING EYE

Many people have strange ideas about how a photographer works. I've met many amateurs in my travels. Often they suspect it's all a matter of tricks, that pictures are created by special lenses, filters, and fancy equipment, or that it's all done in the darkroom by manipulation. They don't believe me when I explain with what simple means most of my photographs were taken.

Of course, having the right equipment is important. A professional will buy the best he can obtain. Also, it's fun to experiment with new films, filters, and lenses, and I sometimes learn useful things this way, but if necessary I could get along with very little. If I were limited to just one camera and one lens I would take a 35-mm rangefinder camera with a 35-mm lens. That, with a good exposure meter, tripod, a filter or two, and a photoflood would fit into one gadget bag. It would be sufficient, really, for most of the work I have to do.

Far more important are your eyes, your brain, and your nervous system. What you see and how quickly you can respond to it—these are the qualities that make a photographer.

No matter where you live or travel there are good pictures. I keep looking and shooting all the time, not just on the job but between assignments, on weekends, and during vacation. Some of the photographs which have pleased me most were done just for the hell of it.

It's really a matter of observing; of coming back again and again if you think you can do the picture better another time, of being ready to stop your car and jump out anywhere, of being constantly alert to the sudden unexpectedness of life, which so often provides you with your best opportunities.

The pictures in this section all just "happened." I didn't plan or expect them. Some were made in exotic locations, others in the most commonplace surroundings. They were discoveries, like the "found objects" that some contemporary artists use in their work.

I was on assignment in South America in 1958 and happened to pass through Guayaquil, Ecuador. I noticed a small shrine and stepped inside. An old Indian woman was sitting on a bench in front of a crucifix. It was a touching scene, come upon quite unexpectedly. I had my camera with me and quickly photographed it—as shown, on the opposite page.

If you come upon something you like, don't hesitate—act immediately. Don't worry about equipment, lenses, or exact exposure readings. There usually isn't time. Whatever lens you happen to have on your camera, fine: do everything you can with that. Shoot first; then, if there's time, try variations. I'm convinced a good photographer can make beautiful pictures anywhere with the simplest of equipment.

If I weren't so restless I'd like to be an amateur painter, but I can't sit still long enough. Therefore I'm a "Sunday photographer."

I found this particular view of Athens on a Sunday afternoon in 1934. (See opposite.) I liked the white buildings and the pattern of shadows. I focused and waited and, eventually, the horsedrawn cart came out of the side street, giving me just the interesting detail I wanted.

The "driftwood dance" I discovered on a Saturday afternoon while walking along the beach. For once, I didn't have my camera with me. I couldn't sleep that night. The next morning I went back to the beach again and photographed the objects in silhouette with sunlight glittering on the ocean.

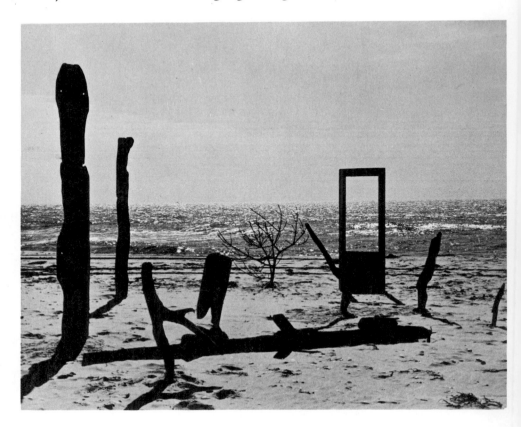

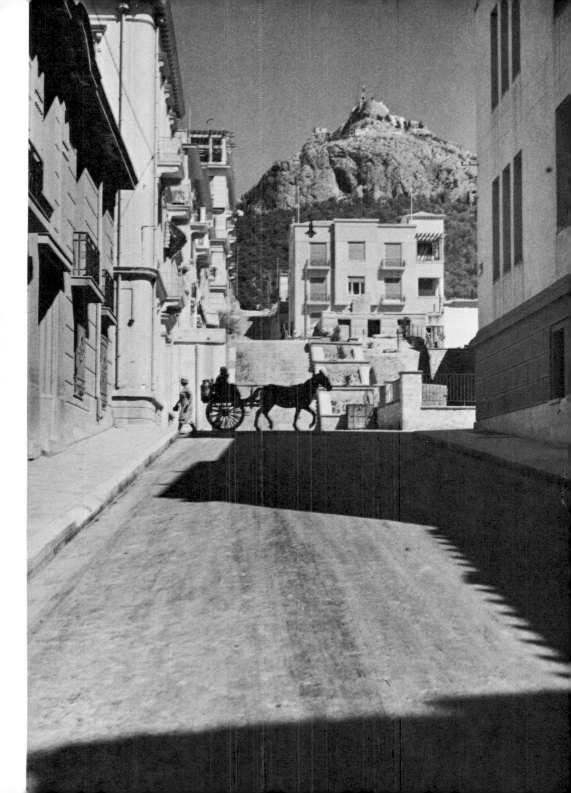

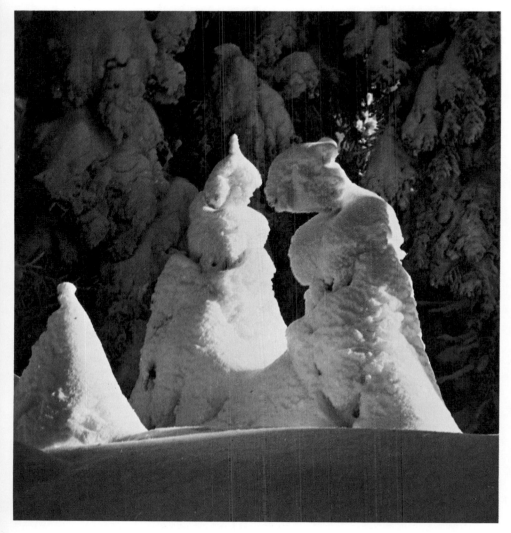

Some pictures are discovered easily, and others only after much searching. I found the two carabinieri in Milan during the early thirties in an arcade just outside La Scala. There they were, their characteristic hats and capes sihouetted against the light. I followed them a bit and made my picture.

For the "three little bears" I nearly froze to death on assignment at Mont Tremblant in Quebec. It was about 50 below. I worked on snowshoes, keeping my Rolleiflex under my coat next to my body so the shutter wouldn't freeze.

People sometimes ask me, "When you go off on an assignment, what do you have in mind?" The truth is, unless the briefing from the editors is very specific, I don't usually know. I may have nothing consciously in mind. I have to see things first. You never know what you'll discover.

The photograph opposite made in Oklahoma in the 1940s is a good example of this. While driving through a small town in Oklahoma, I stopped for a while and looked around. I had my Leica and a 35-mm or 50-mm lens, I don't remember which. As I walked down the street, three men came toward me. I quickly focused and shot.

The abandoned car (overleaf) also was pure discovery. We drove around the Oregon countryside looking at abandoned farms. I saw this old car, liked it, and made the photograph.

On an assignment, of course, your eye must be tuned to look for the details and discoveries that are relevant to the story, not just those which appeal to you. Here, I was documenting the poverty and decay of farmland. However, this was a point of view only; I could not have predicted beforehand that I would find *these* particular pictures to help tell the story. A photojournalist must make his most important decisions on the firing line, with the reality of what he encounters. This, I might add, sometimes is hard for editors sitting back in their offices to understand.

128

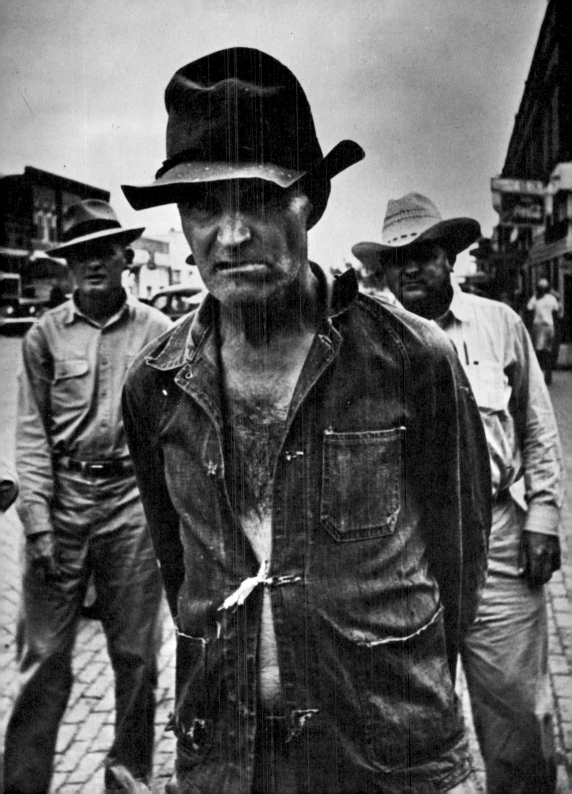

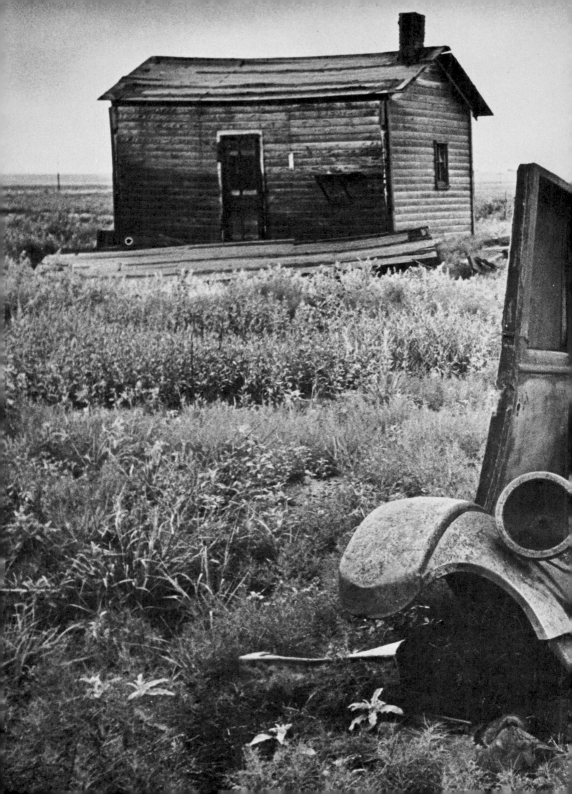

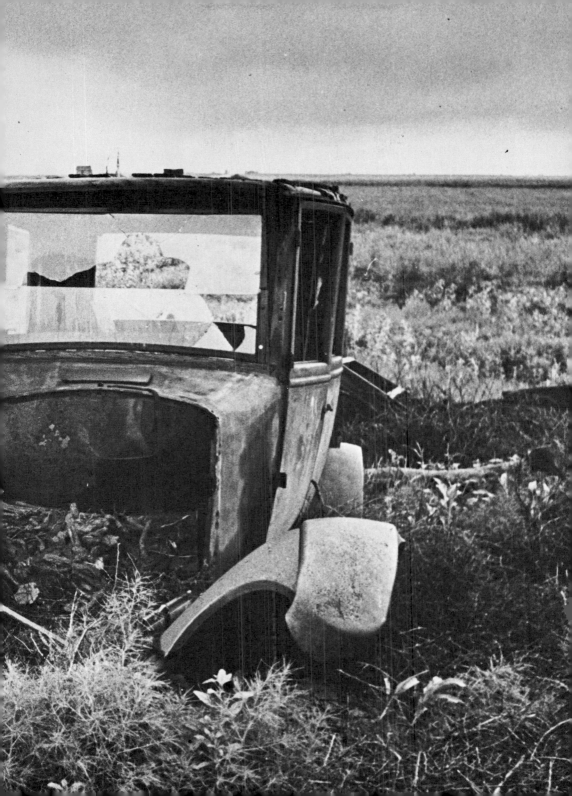

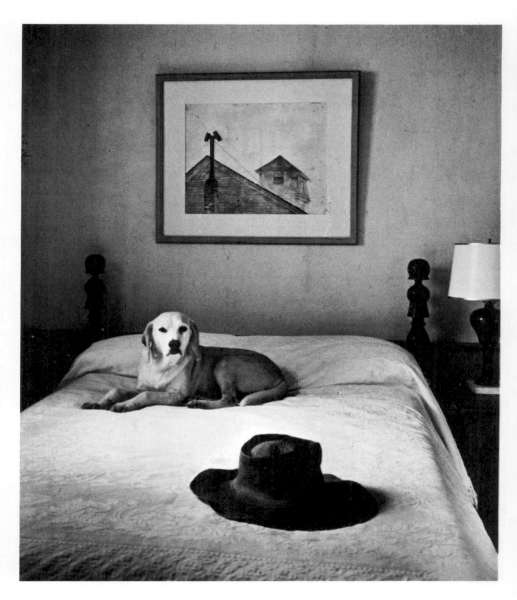

Both these pictures were unplanned. I looked into Andrew Wyeth's bedroom in Maine and saw the bed with both hat and dog lying on it. "Good picture," I thought, and quickly made a few exposures. Then the dog jumped down. I took a second look. Perhaps the dog really draws too much attention to itself and

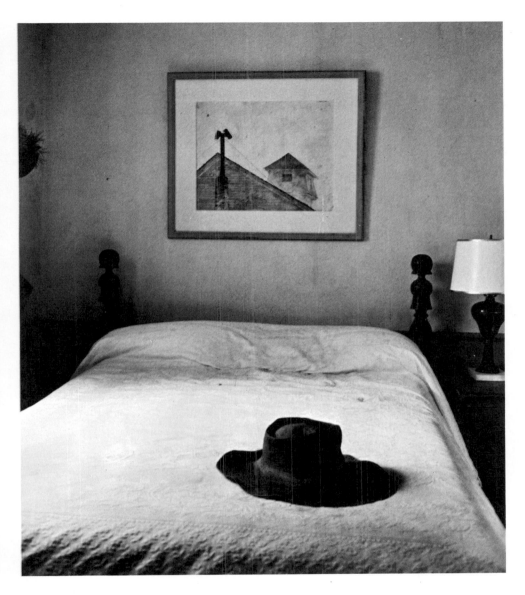

eliminates some of the austerity of the little room and the atmosphere I wanted to capture. It is, you might say, a gimmick. So I took another picture. It's always wise to photograph more than one variation, if you have time. Then you can make a choice later.

Good pictures are under our noses, everywhere, all the time. The photographer learns to see things other people overlook. I love the sea and the beach, for example. They provide an inexhaustible source of pictures. No matter how familiar a beach may be, I'm always finding new things of interest.

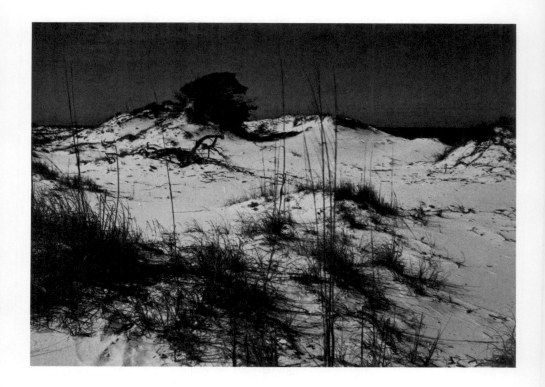

Above is a photograph taken on Florida's Pensacola dunes. The curve of sand dunes and grass makes a pretty scene, but you shouldn't content yourself with just an over-all view of a subject. Are there other pictures, little details hidden within? Look more closely. At that same spot and at the same time, I found many beautiful patterns made by the shadows of tiny beach plants. At right is just one of them. Other photographers might have made other discoveries, but I believe that in that one small area of beach you could find subjects for many thousands of photographs and still not exhaust its possibilities.

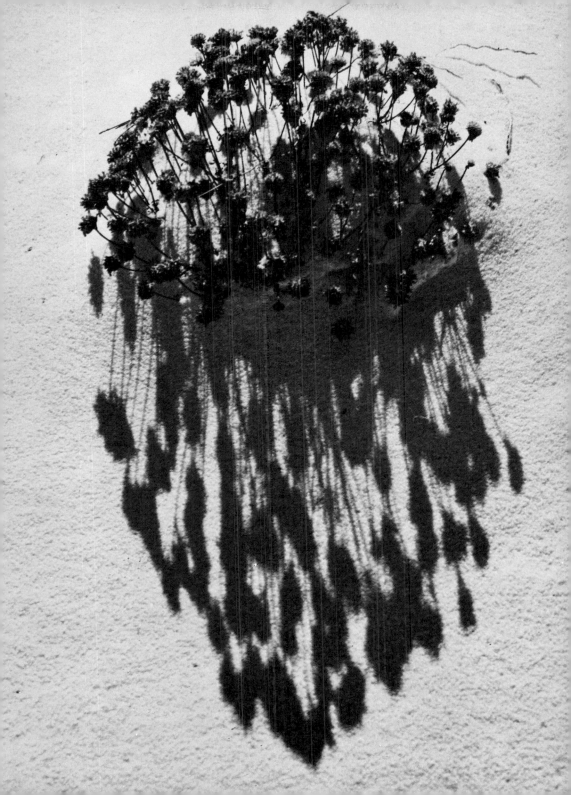

There is beauty and meaning to be found in the humblest, most commonplace subject. Here the subject is an old shack—a rather unpromising object to photograph, yet it contains many possibilities, too.

136

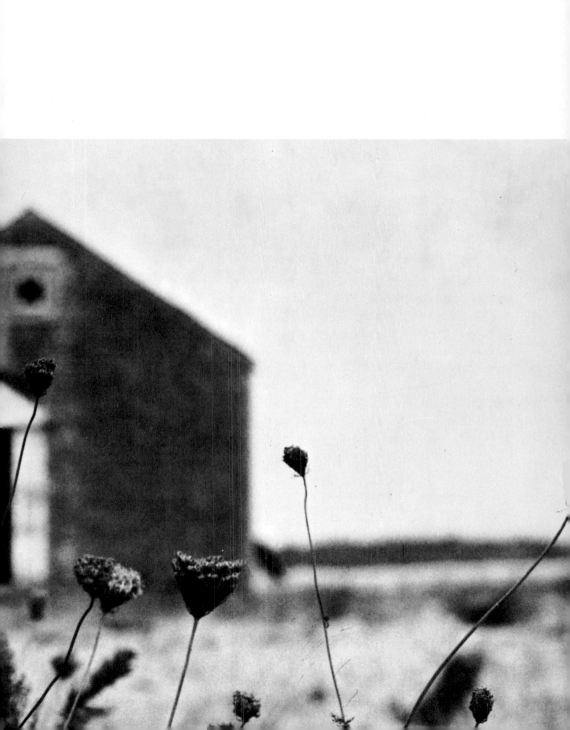

The use of an unusual film or filter sometimes can make the ordinary look quite extraordinary. The unworldly colors of the purple ferns in this photograph taken along the Mianus River near Greenwich, Connecticut, on a dark, damp day, were made by using Infrared Ektachrome film. I had experimented with infrared color film before and expected the green to come out a flaming red, as it usually does. However, this particular batch of film was close to its expiration date and I hadn't kept it refrigerated, as you ought to do when you store color film. The result was colors I'd never seen before—but I liked them, anyway. The exposure was about one-half second with the lens of my Nikon stopped way down, and the camera on a tripod.

There's been a lot of interest in infrared color film. I've had fun with it but find it highly unpredictable. Depending on the quality of the light and the amount of infrared illumination it contains, the speed of the film can range anywhere from about ASA 64 down to 4 or 2. I usually bracket my exposures, taking one at the estimated exposure and a few above and below it, and hope for the best. (A conventional exposure meter is not a reliable guide in such cases.)

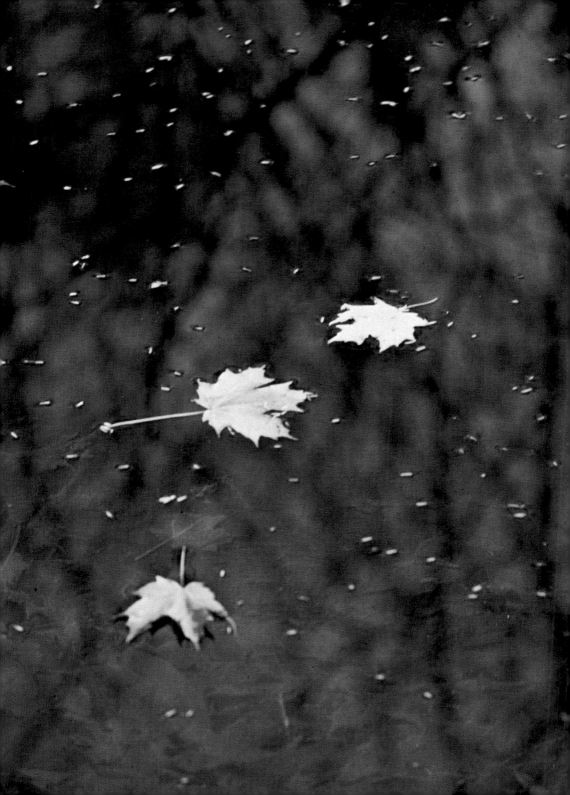

One of my favorite spots is the Mianus River Gorge. It's a wonderful place for a photographer to explore. The color picture on the facing page was made there in the fall, with the dead leaves floating on the water. I used a polarizing filter, which is often useful in my color work. When properly adjusted it darkens blue sky, or, as in this case, the reflection of blue sky in the water. The photograph was taken with a Nikon F on Kodachrome II. I especially like a single-lens reflex for this kind of picture. The inanimate subject allows leisure to concentrate on composing.

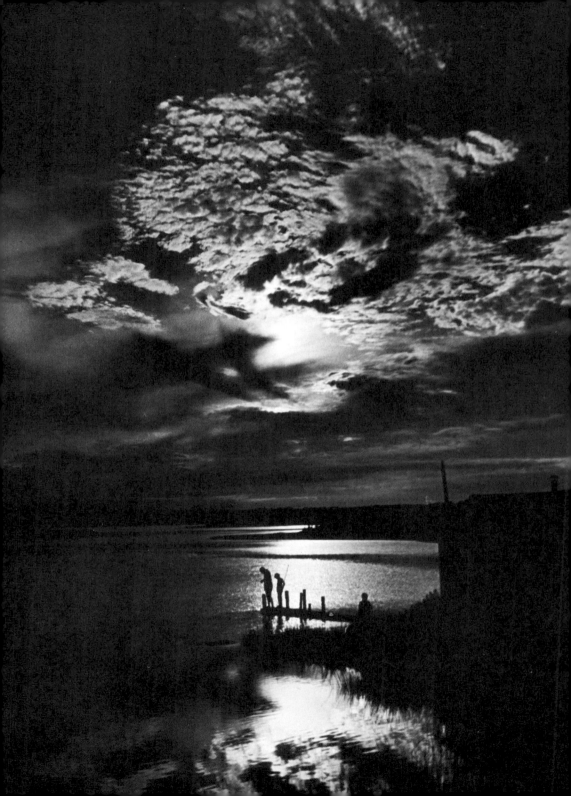

The four photographs in this section all just happened, too. The photograph opposite was made at Dutcher Dock, Martha's Vineyard, in 1967. I know this location very well. There was a particularly lovely sunset, so I walked down to the water. The tiny figures fishing on the pier added just the right human touch. While on assignment in Naples in 1947 doing a story on conditions in post-war Italy I took many, many photographs, with people and without. I was walking through a very poor quarter of town when I found a narrow street with washing hanging on lines strung from one building to another (page 144).

In 1934 I was on assignment in Aleppo, Syria. The best thing for a photographer to do when he visits a city is to walk about, looking and observing. I wandered through a roofed bazaar and found a trader sitting among his wares, right out of the *Arabian Nights*. Again, like so many of my photographs, this one was made "off the cuff" (page 145). For the photograph on pages 146 and 147 I had to hustle. I was in Florence, again walking about, when I saw a double column of black-and-white-robed girls not far away up the street. I had to chase after them and just had time to stop, focus, and shoot as they crossed the street.

Looking for, and finding, the unexpected pictures like these are for me the joy of photography.

The camera lets you see ordinary objects in extreme close-up. The results can be startling and beautiful. My most enjoyable experiment with this kind of photography resulted from an acquaintance with a man who raises orchids as a hobby. Wandering through his greenhouses I became fascinated by the weird shapes of orchids. I photographed many, many of them over a period of time, and they have never ceased to intrigue me.

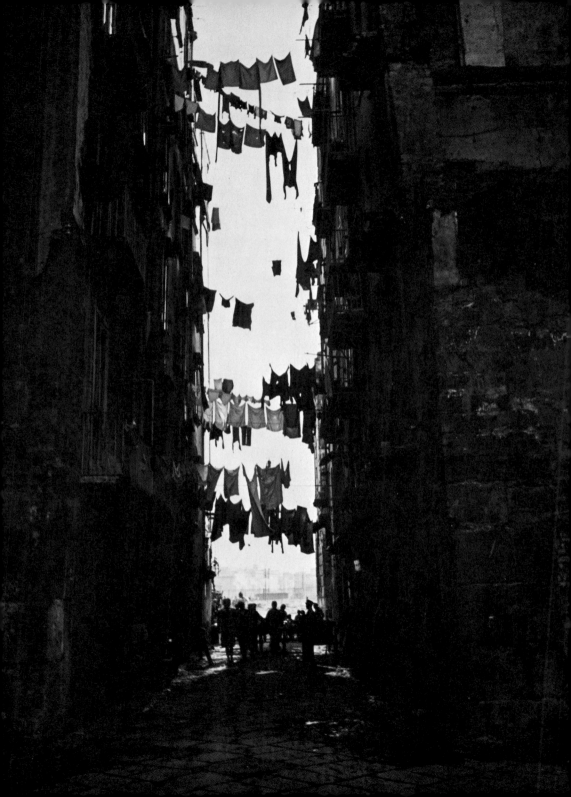

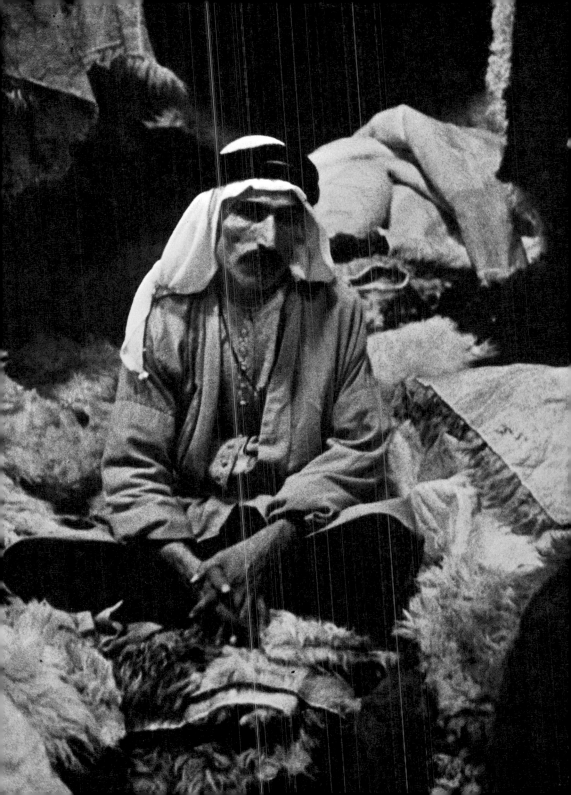

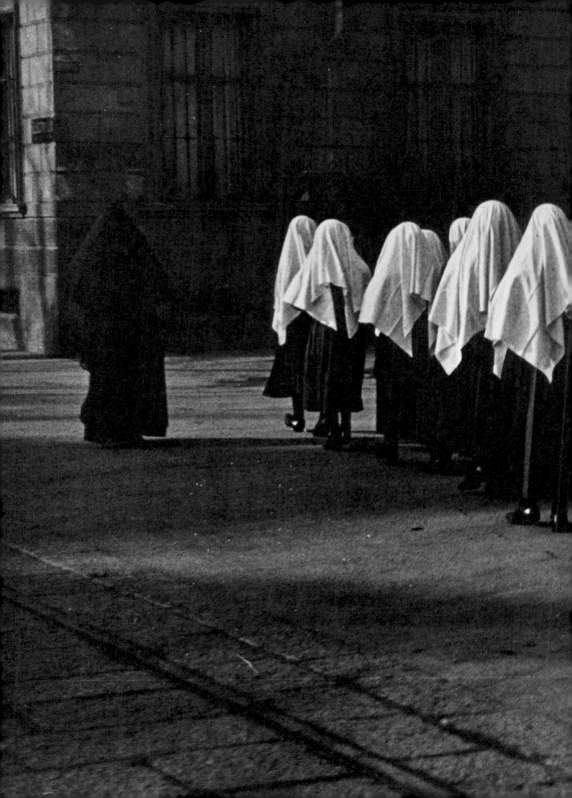

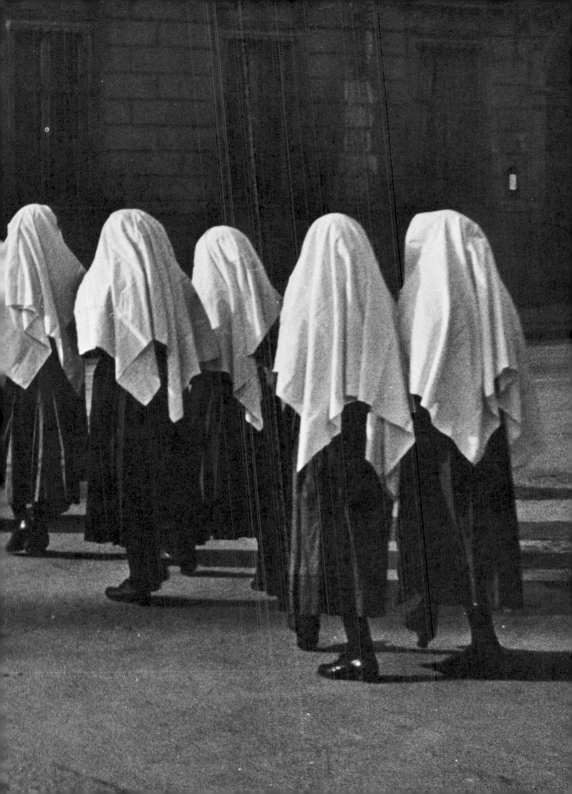

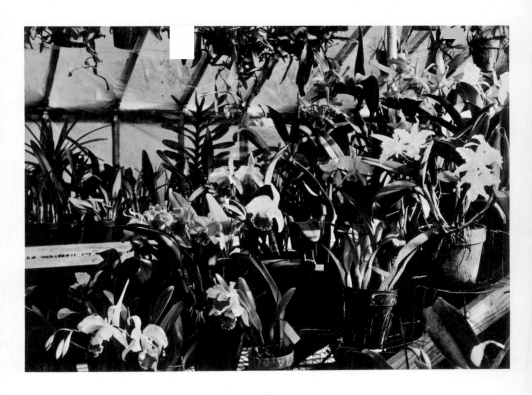

Some special equipment is needed for extreme close-up photography, but it's not difficult. All my orchid photographs were made on Kodachrome film by the existing daylight in the greenhouse. I used an old Leica with a Visoflex I mirror housing, a bellows extension, and a 135-mm Hektor lens. With any good single-lens reflex camera today you can take similar pictures with a long lens and a bellows housing, of which a number of makes are available.

Compare the two photographs on these pages. One is an over-all view of a section of the greenhouse, taken about ten feet away from the flowers. Pretty perhaps, but ordinary. How startling orchids become when seen from very close up! A new universe of shapes and design opens up to you.

Of course I have to stop way down to get enough depth of field for a picture like this, and my exposures may range from three to eight seconds or more. You must allow extra exposure because of the bellows extension, and at the long exposures the quality of the colors may shift. This doesn't bother me. The strangeness and beauty of what my camera captures is more important to me than absolutely faithful reproduction of colors.

148

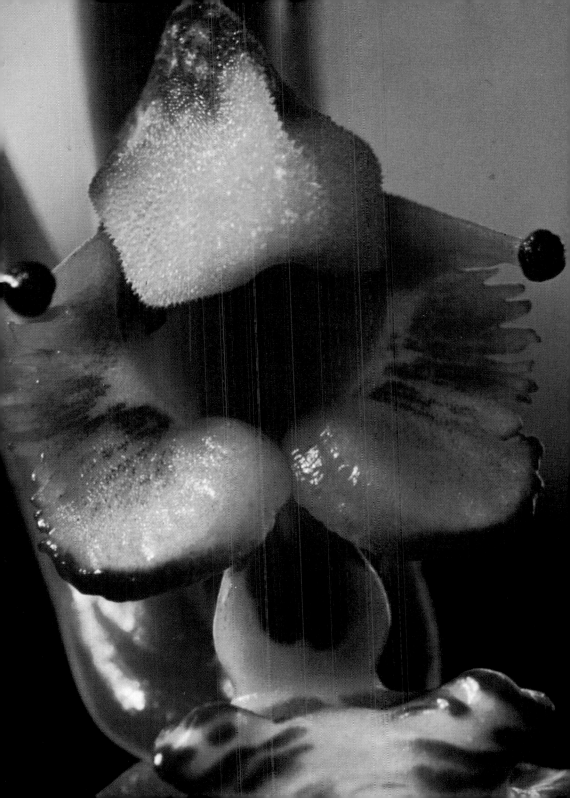

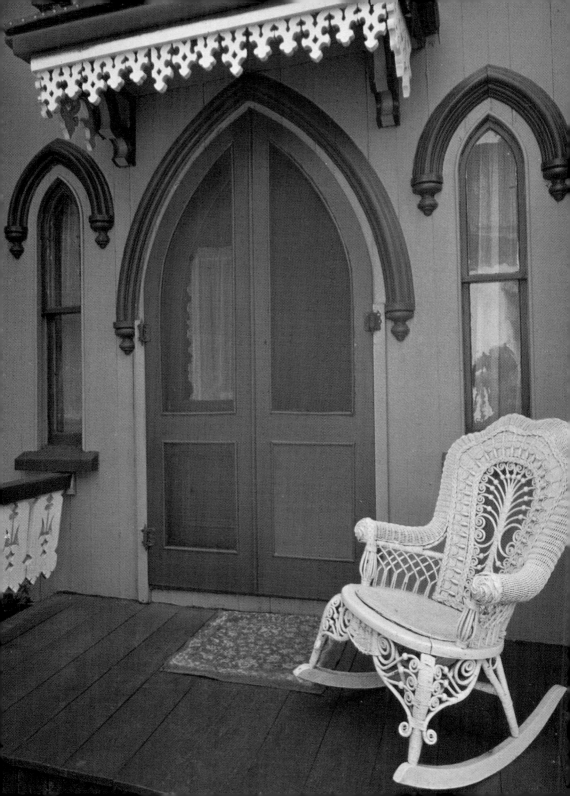

So many things, humble and ordinary things, are wonderful photographic subjects. Chairs, for instance. In the town of Oak Bluffs on Martha's Vineyard there are many little Victorian summer cottages. Almost every cottage has a front porch and every front porch an interesting collection of chairs. I've spent hours "collecting" these chairs with my camera and color film, and I haven't begun to exhaust the subject. One example is reproduced on the opposite page. For color photographs I often prefer the soft light of an overcast day, or shade rather than bright sunlight, because diffuse illumination emphasizes the natural colors of things without a distracting pattern of sunlight and shadow.

BIRDS, ANIMALS, AND PETS

Although it's not particularly a specialty of mine, I've been called upon to photograph wildlife from time to time, in the rain forests of South America and in the Everglades of Florida, to name two places. The most important requirement for success when photographing wildlife is patience, infinite patience. You often must get up early, travel far, and wait for hours in uncomfortable places to get just one chance at a picture. Then you still may miss your shot. It has happened to me more than once.

Other times you may come across a good subject quite unexpectedly. Early in the morning on a dark, rainy day in the Everglades, I was looking out the window of my car when I saw the great white heron shown on the opposite page perched on the branch of a pine tree. I stopped the car. Fortunately, the bird didn't fly away. However, any sudden move on my part would have frightened it. In a situation like this you must move very, very slowly as you raise your camera and focus. You scarcely dare breathe. Here I was able to focus on the bird with a 90-mm lens without startling him.

Obviously, a long lens is necessary for much wildlife photography. I often use a 400-mm or longer lens when photographing shy birds or animals. To get a sharp picture you must focus very carefully, and use a tripod. The slightest vibration will cause blur. My shutter speed for these shots usually is 1/250 second or 1/125 at the very least.

You don't have to travel to the jungles to find good animal pictures. The one on page 154 came about quite unexpectedly; I was in Grand Central Station in New York to get pictures for a story about a commuter train when a cat suddenly appeared. I enjoy photographing dogs and cats: they are as amusing and have as much personality as most human subjects.

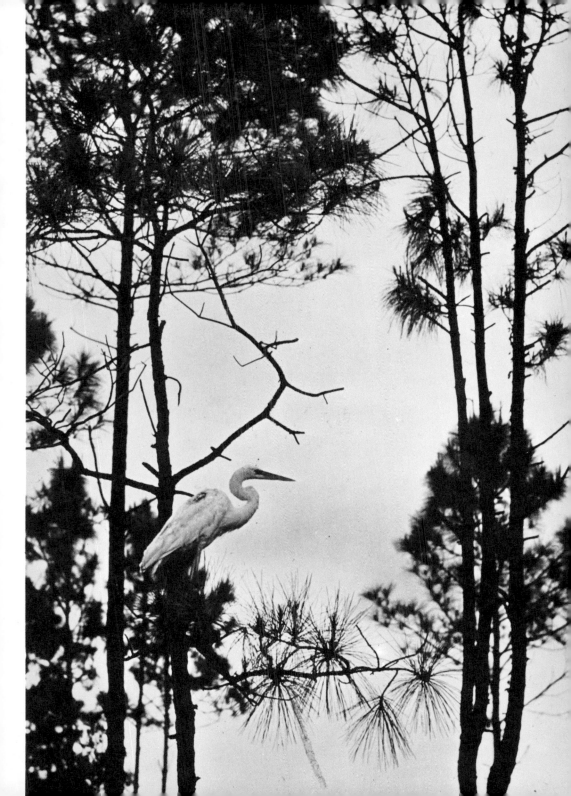

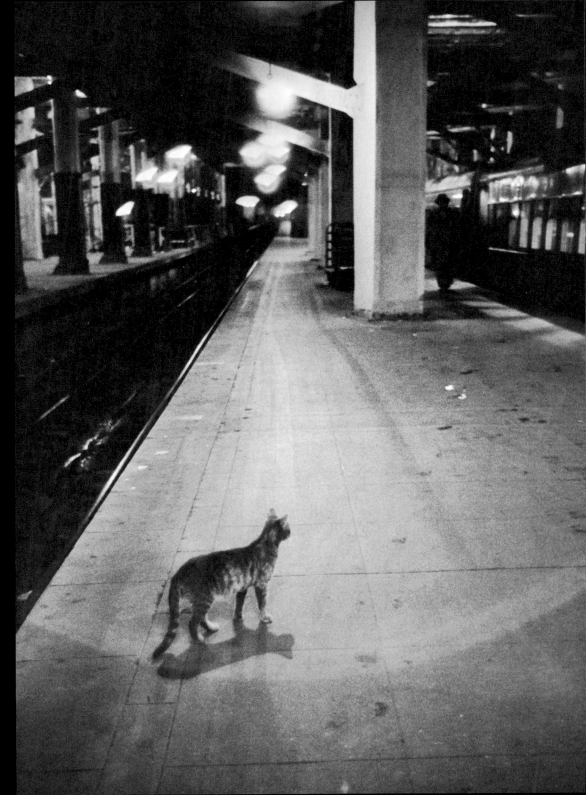

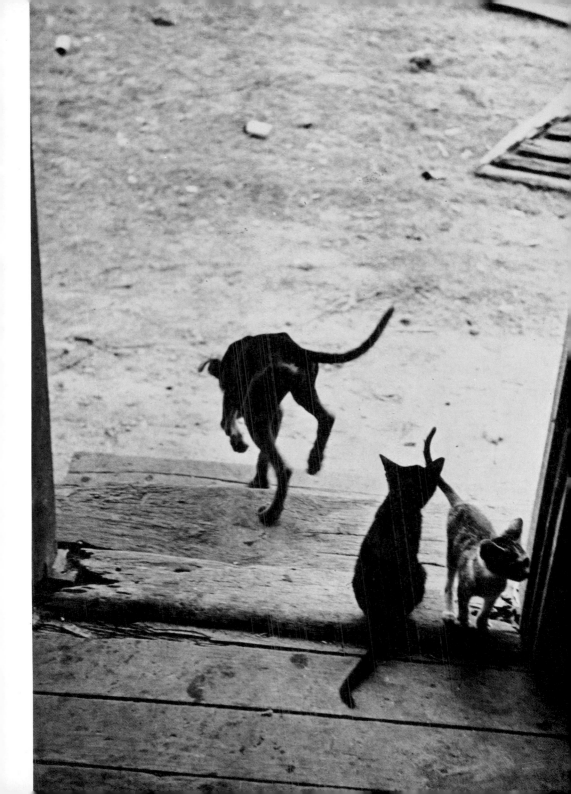

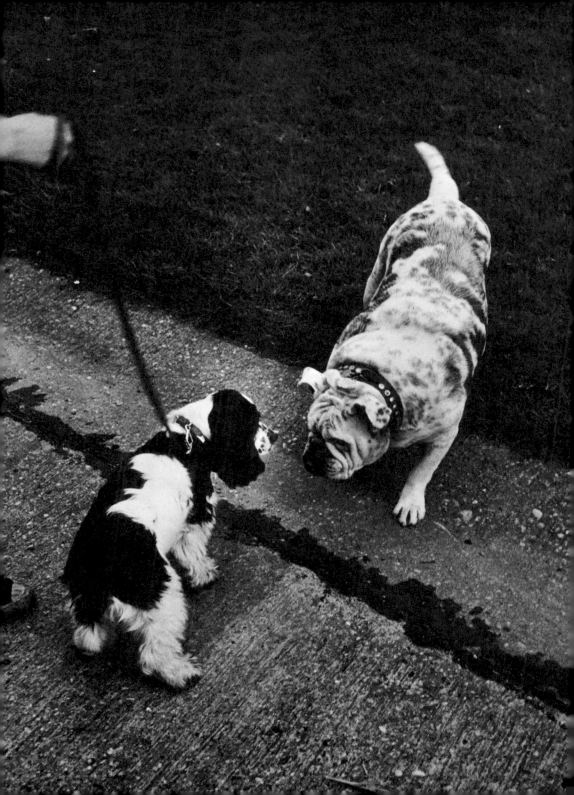

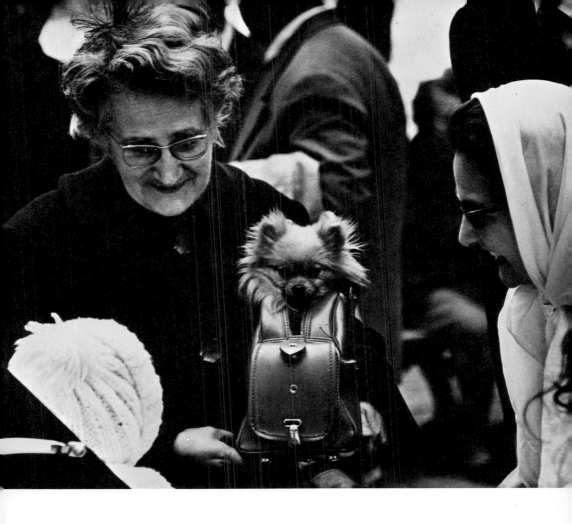

If you use your eyes and respond quickly a dog show offers as much interest and as many picture possibilities as a political convention.

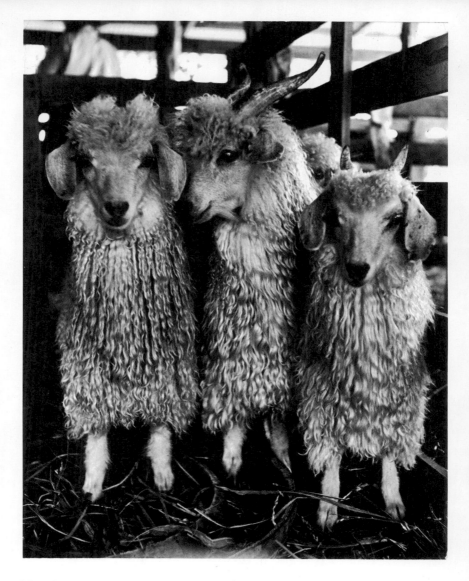

The three Angora goats were photographed in Rockspring, Texas, in 1942. I liked the silky texture of their coats and moved in for a close-up. One turned to nudge his neighbor, and at that moment I shot the picture.

The sheepherder and his flock were photographed in Utah in 1938. I was doing a story on Cecil B. de Mille directing the movie *Union Pacific*. The sheep had nothing to do with my assignment. I was just driving along and saw the scene from the car window, stopped, and made the photograph.

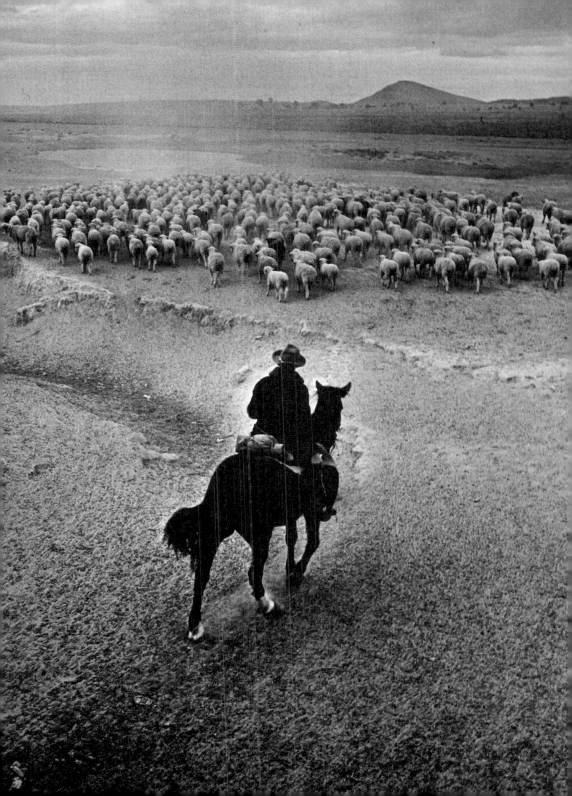

CANDID PHOTOGRAPHY

The secret of true candid photography is simple: not too much equipment, not too much fuss. In my early days as a professional, when available-light photography with a miniature camera was still relatively new, I think it was easier to shoot candids. I didn't look like a professional. I carried very little equipment. People ignored me, or didn't take me seriously, or simply didn't understand that photographs could be made in ordinary room light without flash. All this was a great advantage.

Today, people are more sophisticated, even so it's surprising what you can do if you learn to work quietly and blend into the background.

The photograph opposite is of an attractive girl sitting at a table not far from me, in a café in Paris. I had a moderately long lens on my camera, a 200-mm one. Don't put the camera up to your eye and shoot right away. Go about things easily. Don't stare at your subject. Sit for a while and seem disinterested. Then pick up your camera and swing it past your subject as if you were going to take a picture of something else. As you swing the camera by, focus. (Or focus on some object that is the same distance from you as the subject.) After a time people will forget you're there. Then, very casually, you can pick up the camera again and swing past your subject, stopping just long enough to take your shot. I prefer a rangefinder camera for this kind of shooting because the shutter is quieter than a single-lens reflex.

A telephoto lens can be of considerable help in candid photography, just as it is for photographing wildlife, because it lets you shoot from a distance. The photograph reproduced on the next pages was made with my Leica, a Visoflex reflex housing, and a 200-mm lens. It was taken as part of my Paris essay.

I was walking across a bridge over the Seine leading to the Isle de la Cité in 1963 when I noticed a group of students on an embankment below. They were working very hard at doing nothing whatever. I stopped and took a number of photographs of them without being noticed (see overleaf).

160

A wide-angle lens can be useful in candid work, too. Here, I used a Leica with a 21-mm lens stopped down to $f/11$. This gave me great depth of field, sharpness from about three feet to infinity with no need to focus. I was using Tri-X film rated at ASA 400, allowing a shutter speed of 1/125 second.

I walked along the crowded streets of an old quarter of Paris, my camera on a strap at chest level. Whenever I found an interesting face I'd turn and trip the shutter, without raising the camera to my eye. Obviously, there wasn't much control over composition, but some of the resulting pictures were interesting. The woman at left wasn't aware that I was photographing her: perhaps she just didn't like my looks.

In 1943, in Pennsylvania Station in New York, I photographed servicemen saying good-by to their wives, families, and sweethearts. I used a Rolleiflex for this because when it is held at waist level and prefocused, it is very unobtrusive. I had little difficulty in shooting unobserved: the real problem was to find and catch the storytelling moments. The contacts and enlargement show a little sequence of one couple embracing (see overleaf).

165

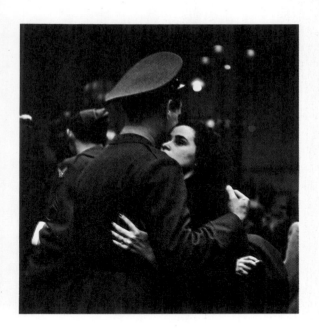

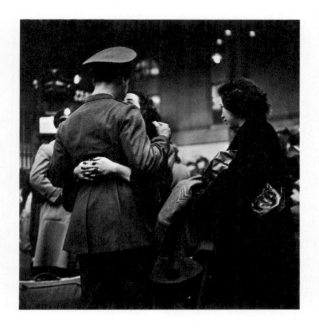

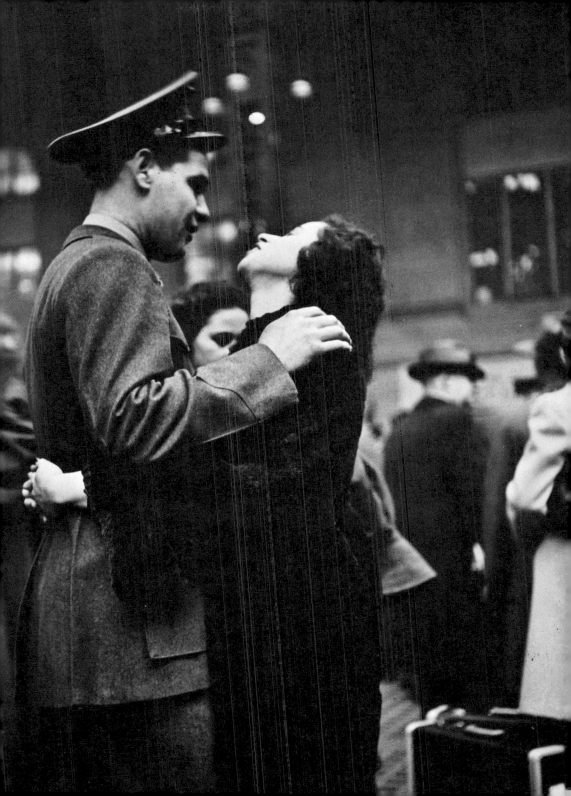

Cleo

It is easy to take candid pictures of crowds. People are so absorbed and excited they tend to ignore photographers. The problem is finding good pictures in the general clutter and confusion. One approach is an over-all view, as in the photograph at left in Canada in 1959 during Queen Elizabeth's visit. I took it from an open truck following her entourage. Another approach is to pick out an interesting individual for a close-up. In moments of high emotion, faces and expressions can be wonderful. The woman above was photographed during Richard Nixon's 1960 presidential campaign.

At press conferences and public events, there is rarely much room for maneuver, especially in competition with television cameras and crews. You may be assigned to one spot, and that's it. When I was assigned to cover the Kefauver hearings on organized crime I fortunately got a place directly in front of the star witness of the day, Frank Costello. I used a long lens, available light, and a 35-mm camera. Nailed to the spot like this, there's nothing much to do but concentrate on expressions and gestures. The picture at right, as a visual statement about the man and the moment, was my most successful one.

The following spread is a photograph I made during the 1952 Republican Convention in Chicago. Political conventions are exciting but a madhouse to cover. Results are candid, all right: nobody cares about you amid all the commotion. For this picture I used a wide-angle lens to include many delegates and capture the atmosphere. The picture has a central point of interest, though: Sherman Adams. Look for the key figures, the well-known faces, and catch them.

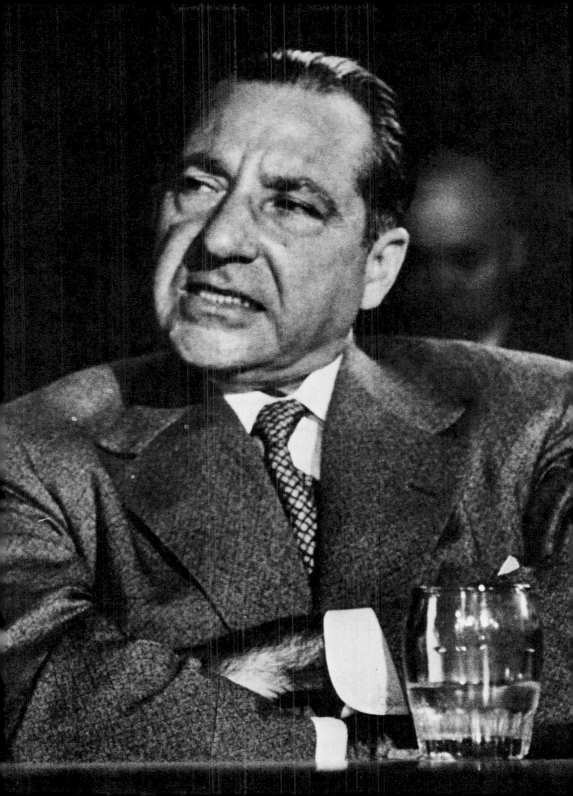

As photographers we sometimes tend to be egotistical and self-conscious. In making candid photographs, however, you take advantage of the fact that most people are much more interested in their personal problems and activities than they are in you as a photographer. If you approach them softly, unobtrusively, it is amazing what you can accomplish.

All the photographs on pages 174 to 181 were taken by me of subjects who were much too involved in themselves to notice or worry about a little man with a small camera.

The stamp collectors were photographed as part of my Paris essay. They were so involved in their stamps that I was able to push my camera almost into their faces without disturbing them.

The harp concert was taken at a tea in Atlanta given by the Daughters of the American Revolution. I loved the wonderful faces of the old ladies. They knew I was there photographing, but at this point, the concert was the focus of attention and I might as well have been invisible.

The sharecropper family at prayer on pages 178-179 was made in 1936, one of my "test" stories before the first issue of *Life* appeared. This was a very poor family but one with great dignity and kindness. I spent much time with them. They accepted me and carried on their daily life as usual, without being self-conscious or inhibited. Today, with the increase of racial tensions and problems, I don't suppose I could take this kind of photograph. My documenting of poverty might be resented.

The photograph on page 180 dates way back to 1933. I took it one afternoon in the Rijksmuseum in Amsterdam. A woman in Dutch costume and her grandson were visiting the museum. I doubt that they had any inkling that photographs could be taken inside the building. I took several pictures, and the strongest one turned out to be of them standing in front of the painting—as shown. (Unfortunately, I have lost the original negative and have only a copy to print from.) Early available-light photography—there was a touch of magic to it then!

As you can see, when you are shooting candid photographs you don't always have the time or opportunity to worry about refinements in composition or lighting. However, you can train yourself to be aware of these qualities so that you respond almost automatically.

While in a church in Addis Ababa, for instance, I was making photographs unobtrusively. I was looking for anything interesting—shadows, shapes, actions. This is what I suddenly saw: the person inside kneeling down—a dark silhouette— with the woman in white brightly sunlit outside. I shot very quickly, the camera hand-held (page 181). A snapshot, really. Yet if I'd had complete control over my subjects and the opportunity to pose and direct them, I don't know what I'd have done differently.

Pictures, beautiful pictures, appear spontaneously. The photographer's eye recognizes them. If you are quick enough, you catch the moment before it dissolves forever.

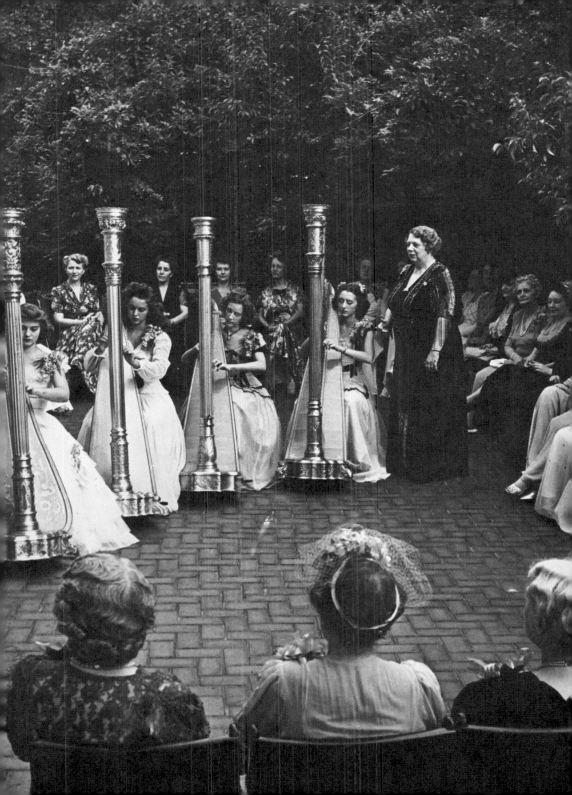

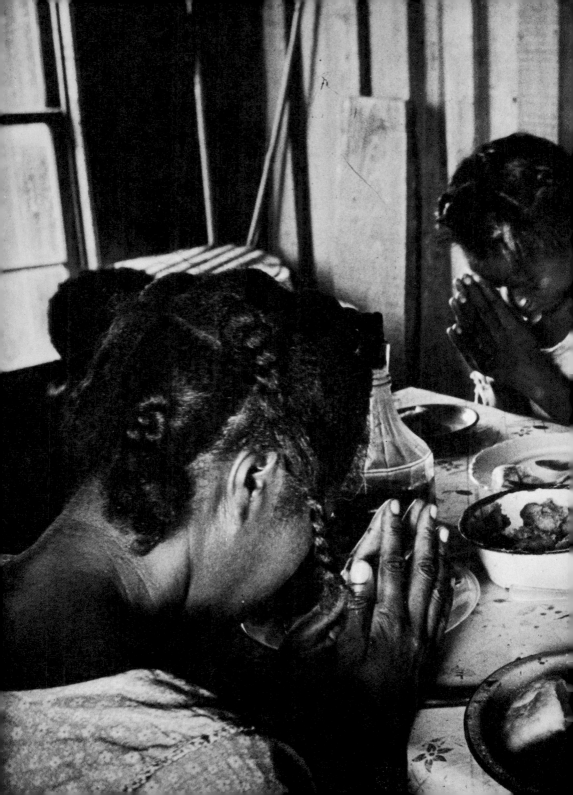

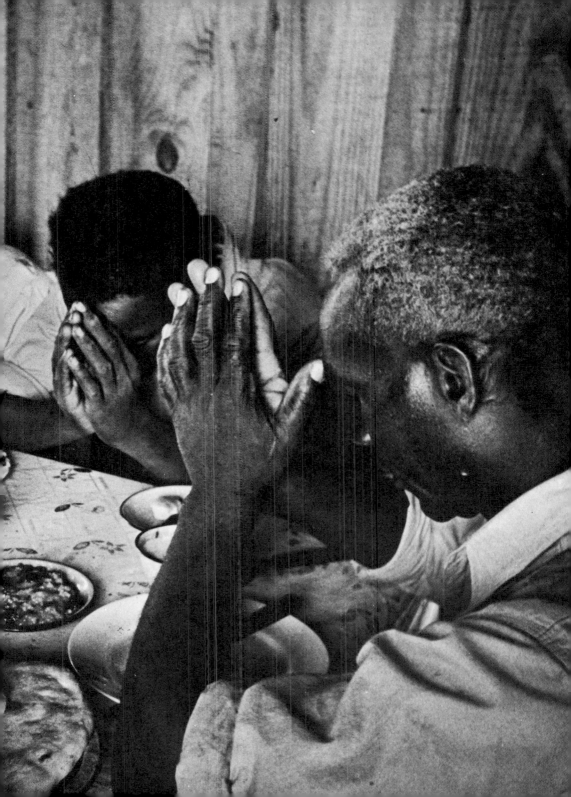

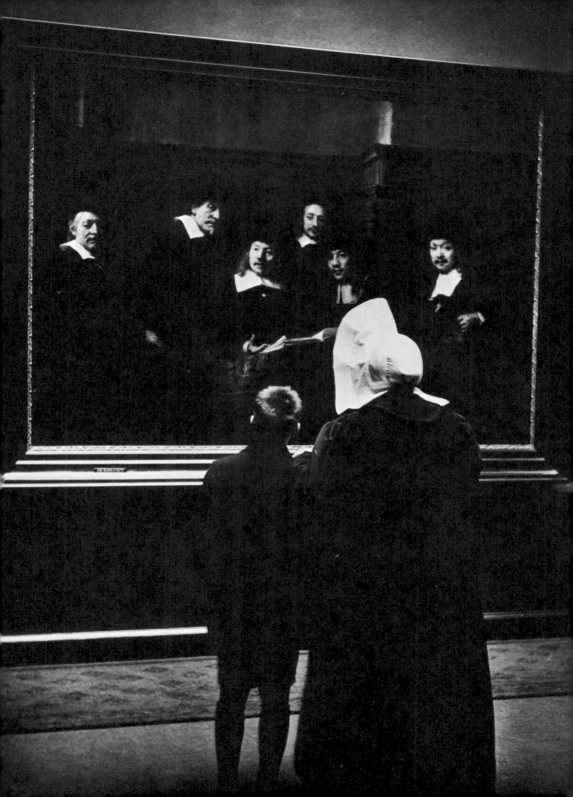

PHOTOGRAPHING CHILDREN

I love to photograph children. They are sometimes exasperating, but almost always fun, and they do unexpected, wonderful things. You can't be stiff and remote with children; you have to loosen up and become one of them. Because I am a small man and don't tower over them, it may be easier for me to photograph them than for others. I think the photograph below visually sums up my approach. I just let myself go, having as much fun as the children.

This photograph of a Chinese mission school in San Francisco's Chinatown was made during one of my very first assignments for *Life*. I caught this group on the steps of the mission, absorbed in the books they were holding.

The photographs on pages 184–185 were made in Canada in 1959 while I was covering Queen Elizabeth's visit. I was waiting with my camera ready, expecting the Queen to come out of a building at any moment, when suddenly a little girl broke through the lines and ran in. I caught her coming toward me, then again, just as two Mounties reached out to stop her. That was *the* picture, of course— much better than the head-on view.

In 1963, when I was assigned to do an essay on Paris for *Life* International, they gave me complete freedom. It sounds like a perfect assignment but actually was very, very difficult. Where do you begin? What do you concentrate on? I finally decided to show the city primarily in terms of its people, and of course children were very important.

The photograph on pages 186–187 was taken at a Punch and Judy show. I tried many angles, but none satisfied me. Finally I moved in *front* of the children to catch their reactions full face. The stage was just above me. I prefocused and kept popping up and down at exciting moments. The children were so absorbed in the play they soon forgot about me. The expressions were wonderful and I took many pictures that I like very much.

182

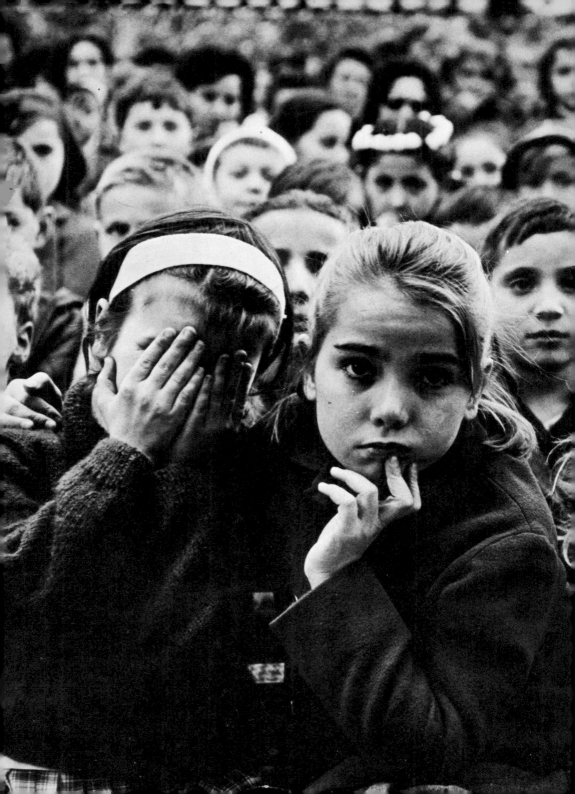

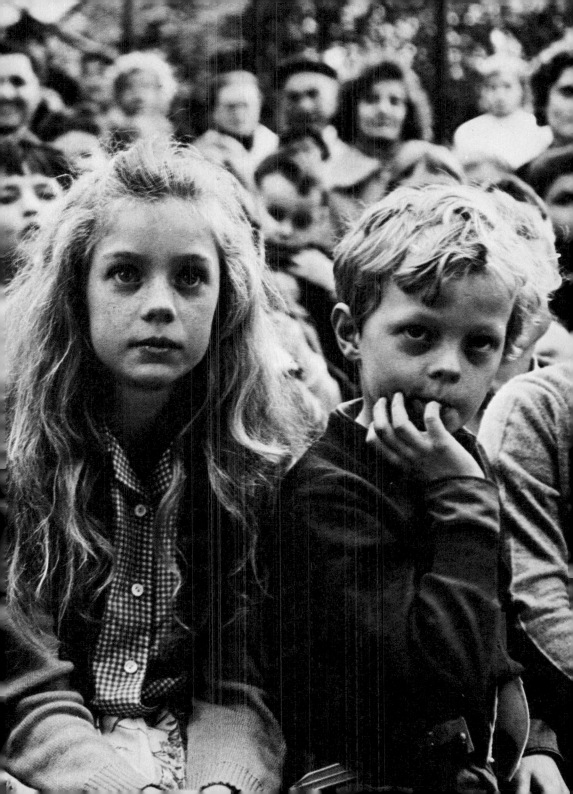

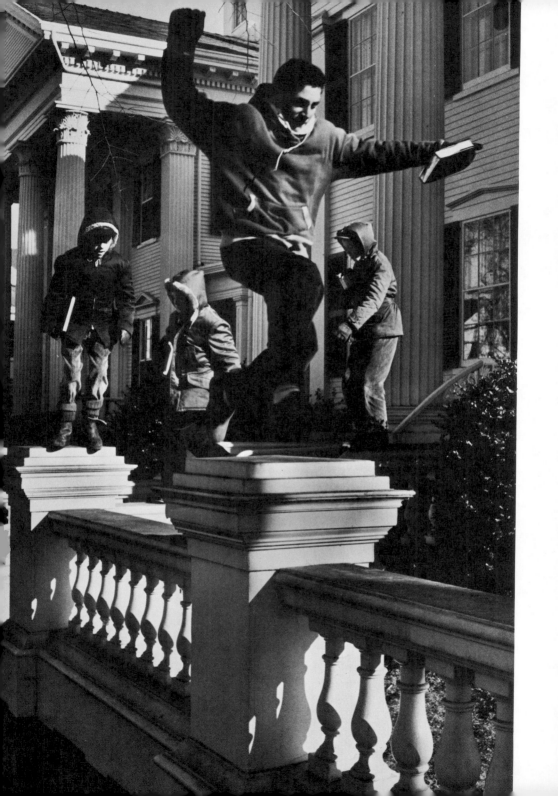

The most extensive story I ever did on young people was made in January 1959 on Nantucket Island. It appeared under the title, "Winter Joys of Children, Summer Left Behind." Although this was an assignment for a magazine, it's the kind of thing that any photographer could do for himself in any town.

In this case there were difficulties. The first boy selected didn't want to be photographed, so we went around and talked to a number of others until we found a group of friends who were willing to cooperate with us. Eventually, the first boy changed his mind and came back in again after all.

The story required direction, but direction of a special kind. First, you've got to ask people questions. You must gently pry into their private lives to find out *what* they do and *where* they do it. Then you go out and re-create the real, the natural things. However, the youngsters must like and trust you. In being inquisitive you must not be an intruder.

Opposite and overleaf are two results. The photographs are not candid in the strict sense of the word because the boys knew I was photographing them, but the situations we re-created came out of the boys themselves. I think the pictures reflect this.

The photograph on pages 192-193 was taken in 1960 at the Kennedy summer home in Hyannisport. Although the subjects were famous, the problems I encountered weren't very different from what any photographer of children meets from time to time. Jacqueline Kennedy was wonderful to me and most cooperative. Caroline, however, was difficult, which isn't unusual for children at that age. If you ever find yourself not getting the response you want from a child, you might try what I did—work through the mother. Mrs. Kennedy was most helpful in carrying out the typical family activities with her daughter. This freed me to concentrate on capturing the right moments.

A hurricane prevented me from leaving on schedule. At about nine-thirty the lights went out. Candles were lit, Caroline had to go to bed, and I thought my picture-taking was over. However, the electricity came back on and I was able to make a photograph of the mother and daughter reading a bedtime story. You often get your best pictures toward the end of a shooting. Be sure to carry enough film so you don't get caught short!

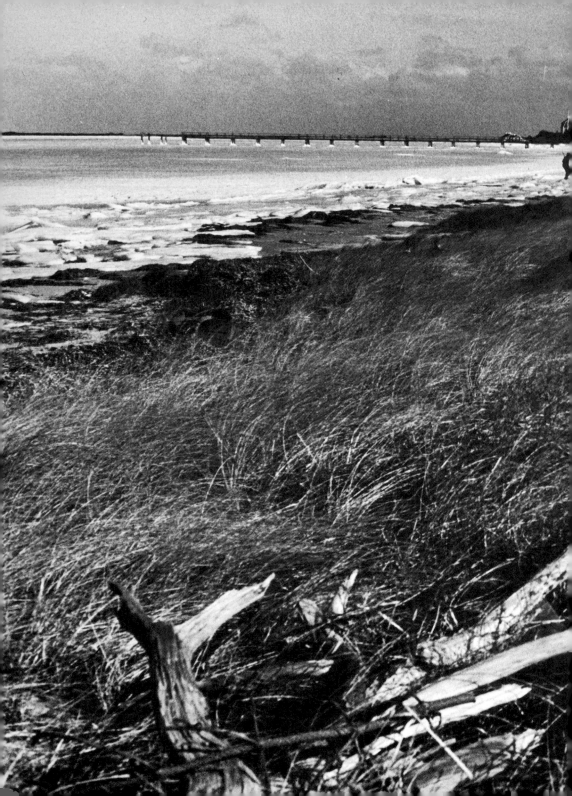

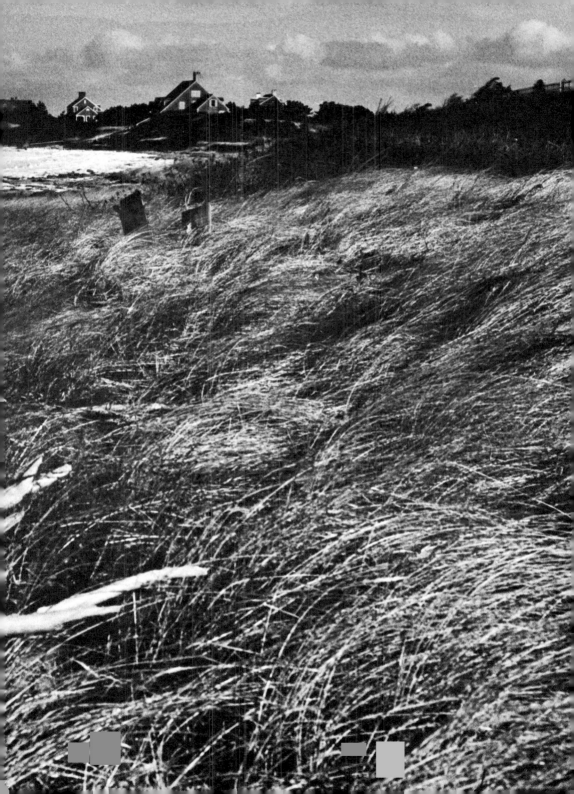

VIEWS FROM MY WINDOW

I have traveled all over the world in search of pictures, but I've found some very exciting ones close to home from the bedroom window of my apartment. We have a good view of the New York skyline from that window and the best time for shooting comes between March and September, when I can catch the setting sun directly in my pictures. The early fall is particularly good because the air is clearest then.

For the past ten years or so these window views have been a self-imposed assignment for me. This is very important. Most professionals are paid to take on any assignment given to them, and naturally they like some better than others. But you also should always be doing "assignments" you give yourself—things you love. This keeps your work fresh and alive.

The view of the Triborough Bridge was taken at dusk, with the sky still bright, but after the bridge lights had been turned on. Here I used a 500-mm Russian-made mirror tele-lens plus a telextender, giving me an effective focal length of 1000-mm. I made a number of exposures as the light faded. This one caught just the right balance between the sky and bridge lights.

For the picture at the upper right, I saw interesting cloud formations building up, placed my camera in position, focused, and waited. The film, as for all of these, was Kodachrome II.

The picture at the upper left shows a helicopter landing on the Pan Am Building and was made with a Bushnell telescope on the Leica, giving me an effective focal length of about 1500-mm.

The picture on the following page shows the sun directly behind the Empire State Building. This happens only for a few moments on one evening during the entire year. I used my Leica, a mirror housing, and a Bushnell telescope. The exposure was $f/22$ at 1/30 second.

Sometimes I use an 05R filter for my sunset shots to make the sky even redder. In calculating exposure, I've had the best results by using a spot meter. I used to tend to overexpose my sunset pictures. Now I read the sun itself (when it's close to the horizon and veiled with haze, of course). The results are more predictable, but I still bracket my exposures.

I enjoy traveling and recording far-away places and people with my camera. But I also find it wonderfully rewarding to see what I can discover outside my own window. You only need to study the scene with the eyes of a photographer.

ON TECHNIQUE

For the beginner, I would like to add just a few words of advice on technique. First of all, it is necessary, of course, to know your equipment inside and out. You must be able to use it comfortably and swiftly. This should come almost automatically with time, practice, and experimentation.

Remember that technique is only a means to an end. It is not an end in itself. The technical aspects of photography are important, but too much preoccupation with mechanics is a common mistake that should be avoided.

In talking to people in many parts of the world, I am usually asked such questions as "What film do you use?" "What filter?" "What exposure?" Rarely am I asked, "How do you *see* as a photographer? How do you find good pictures?"

At one of my exhibitions, a man and his son were talking to me, and twenty-five people gathered around to listen. It was a wonderful bull-session on photography. The man asked me what camera I was using. I told him. He turned to his boy and said, "Son, I'll buy you the same camera and even better lenses and I bet you can do the same as Mr. Eisenstaedt."

I told the man his son might make a very good photographer, but perhaps not right away. I pointed out that it took me years to learn what I needed to know and years more to learn really to *see* as a photographer. Equipment, I assured him, had relatively little to do with it.

"Suppose your son took piano lessons," I said. "Do you think in the beginning he would play better on an expensive Steinway than he would on a relatively inexpensive spinet?"

The man thought about it for a moment. "No. I suppose not," he said. "I see your point."

Certainly the editors I've worked with aren't interested in the problems I may

encounter on an assignment or in how much or how little money I spend on equipment. They are only interested in results: Bring back the pictures!

In photography and photojournalism especially, speed is of the essence, and requires complete familiarity with your equipment. You cannot risk fumbling at the crucial moment. As with every other art, you have to practice and keep on practicing.

If I were starting out again today as a beginner, with the idea of breaking into professional photography, I would buy a good 35-mm camera with a 35-mm lens. This allows reasonable versatility without spending a lot of money. I would also make sure, when choosing the camera, that I was getting one that would take other lenses. As I progressed, I would add a 90-mm lens and then a 50-mm one. With these three lenses, you can do almost everything.

People often ask me to recommend specific cameras. There are hundreds of cameras on the market today, and there are not too many bad ones. However, I can only speak from my own experience. Since 1930 I have used Leica, Rolleiflex, and Pentax cameras. I also use the Nikon F (single-lens reflex) camera for scenery and for other occasions when I can take time for precise composition. But for reportage, where fast action is so important, I prefer a rangefinder camera.

When I go out on assignments, I usually take along my old gadget bag. It's about eighteen years old now and dilapidated. People sometimes say, "You should get a new case, a bigger and better one. Surely you can afford it." My answer is, "Sure, but would it help me to take better pictures?"

One cumbersome piece of equipment that I do usually take with me is a tripod. I never know when I am going to need one. All too often just the picture I want is in poor light, or in some awkward location, making it impossible for me to steady the camera by hand. I also like to use a tripod when making portraits for the reason explained on page 95.

Next to equipment, many amateur photographers I talk to seem to be convinced that tricks in the darkroom are the secret of good photography. They look at me dubiously when I admit I usually don't do my own developing and printing. I used to, and still do occasionally for my own satisfaction, but for my working assignments, it's impossible; there just isn't time. When I come back from a story the pictures have to be *on the film.* Maybe the tonal quality should be deepened, the contrast changed, or the prints cropped. But nothing can be added that isn't already on the film. You have to *see* the pictures on location and capture them.

It is true that a routine, run-of-the-mill black-and-white print serviced by a shop catering to amateurs and one made by a photo laboratory used by professionals can be almost as different as night and day. Any photographer who intends to become

professional either must learn to do his own developing and printing or must rely on a quality service to process his black-and-white films. For color film the general services of local shops are usually quite satisfactory because they send their work out to processing plants franchised by the film manufacturers, or to the laboratories of the film companies themselves.

When I have the time to do so, I enjoy experimenting with lenses, filters, and other equipment. I spend a good deal of my vacation doing this, and often learn things that can be very useful to me in my work. But again my advice is, keep your accessories to a minimum—at least to begin with. Learning to be resourceful and imaginative is a good way to become a better photographer.

Regarding film, I use Kodak film for both color and black and white. Having found something that works well for me, I see no need to keep on experimenting. But, like choosing a camera, this is a matter of personal preference, and there are many other excellent films on the market. For black-and-white work I find Tri-X most satisfactory because of its range, softness, and its excellent reproduction of detail in shadows. Occasionally, for bright snow or desert scenes, I use Panatomic-X. For color I usually use Kodachrome II, sometimes Ektachrome X, and in artificial light Ektachrome Type B. I always carry more film than I expect to use.

I generally use a light meter and, for color, I find it advisable to bracket my shots. Black-and-white exposures can be manipulated during printing in the darkroom, but color film does not offer this second chance.

Frequently I am asked why I do not use an automatic camera with a built-in meter. The answer is that, with a completely automatic camera, I would not have the free control over shutter speed and lens opening that I want for special effects or for handling difficult shooting situations.

Ultimately, it is your eye for lighting, for color, for composition, for human interest that makes the real difference between a dramatic picture and a dull one. You must learn to anticipate situations and to operate the camera as if it were a part of yourself. With a photographer's eye, you can accomplish much with the simplest of equipment.

In conclusion, the best advice I can offer is, don't be discouraged by initial failures, and, equally, don't become too conceited at your first success. During my first ten years as a photographer, I was criticized constantly, and it helped me to improve my work. I still make mistakes every day, and this is how I go on learning. If you want to be a good photographer, you just have to keep on trying, and never think that you have learned it all. There are new things to be discovered every time you take a picture.